Barbara Crane

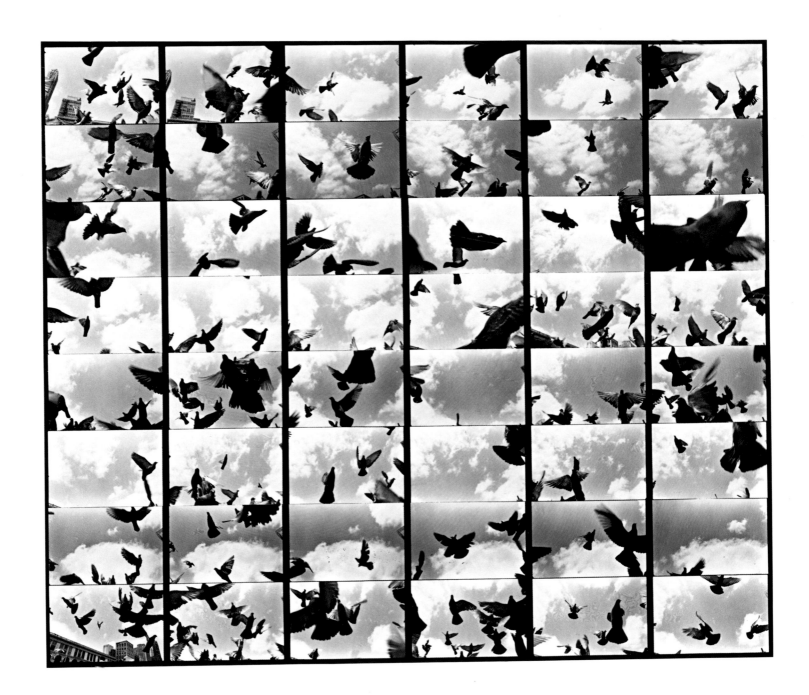

Barbara Crane
PHOTOGRAPHS 1948-1980

Imagination, Phototechnics, and Chance: The Work of
Barbara Crane *by Estelle Jussim*

Recollections *by Paul Vanderbilt*

Center for Creative Photography/University of Arizona

Premier Showing:

Chicago Center for Contemporary Photography
Columbia College
600 S. Michigan Avenue
Chicago, Illinois
April 17–May 30, 1981

This exhibition has been made available for a national tour by the Center for Creative Photography.

This exhibition and book are funded in part by the National Endowment for the Arts (a federal agency), Polaroid Corporation, and private donors.

COVER:
Just Married, Baxter/Travenol Labs, Deerfield, Illinois, 1975, print size: 50.2 x 40.0 cm; mural size: 8 x 8 feet

FRONTISPIECE:
Pigeons, Grant Park, Chicago, Illinois, 1975, 19.7 x 24.6 cm

Contents

Acknowledgments

Since 1948, Barbara Crane has devoted her every thought and effort to the exploration of photography as a means of personal creative expression, as a vehicle for satisfying her need to interact with people, and as an intellectual tool. The result has been a significant body of work greatly varied in approach and uniquely experimental in style.

Yet, she is perhaps more known for her teaching, workshops, and lectures than for the breadth of her photography. This has been largely due to several circumstances. Crane has given a great many students inspiration and enthusiasm for aesthetics and photography. Although teaching and lectures are a primary means for showing one's own ideas and art, they do not constitute a format that can regenerate the shared offerings for a critical assessment. Even participants are more likely to remember the artist than her work. Thus, there is little in the way of literature in the field to which one can turn when the need arises to place Crane and her work in the context of contemporary photography. Like most artists, Crane was reluctant to give over the body of her work and ideas to others who published books, organized exhibits, and formed collections, placing greater emphasis on making it than promoting it. Instead, for many years she melded into group exhibitions and only showed the newest of her work in one-person shows. The large format of much of her work, often mural size, impeded facile exhibition and reproduction. Also an important factor was Crane's responsible attitude as a single parent toward her children and the time and energy devoted to them. The result has been fractured documentation of her accomplishments.

Over the past ten years I have had several opportunities to gather glimpses of various aspects of Barbara Crane's work. We were colleagues first, and then gradually, as I saw more work, I became convinced that the majority of my peers and colleagues did not have an accurate overview of the breadth of her work. She was thought of as a "Chicago/Institute of Design/artist." There is that in her work, but there is also her ability to absorb and experiment with each

new socioaesthetic development in American culture. This book and exhibition, I believe, will reveal that Barbara Crane is a particularly American artist.

The effort that brought this presentation of Barbara Crane's work to the forefront has been the result of extraordinary support from a number of individuals and institutions. Dr. Estelle Jussim's essay, published here, like all her writing, is insightful, critical, and, most of all, conducive to analytical peership, something without which a field never rises to professional maturity. We are most grateful to Dr. Jussim. Paul Vanderbilt, who wrote "Recollections," has provided an additional means of assessing Barbara Crane's photography. Mr. Vanderbilt has known her work and way of working perhaps more thoroughly than any other individual, and his own talents as archivist, author, and photographer have been brought into full play in a special narrative environment for consideration of Crane's photographs.

Every public effort by the Center for Creative Photography involves nearly the entire staff, and I wish to acknowledge and express appreciation for their continued commitment to excellence. With each effort, however, more responsibility inevitably falls on one or another staff member, according to the focus of the project. In this particular case, I would like to express a special thanks to our Publications Coordinator, Nancy Solomon, who sensitively served as literary editor, assisted in the design of the book with the designer Mark Sanders, and attended to details in the production and quality control of the book.

We are also deeply grateful to Polaroid Corporation for making the color section of the book possible and to the National Endowment for the Arts for an exhibitions aid grant.

Finally, this book would not have been as complete or as thorough without the generous donations of the following: The Arlene and Marshall Bennett Family Foundation, The Crown Family, Mr. Arnold M. Gilbert, Mr. David C. Ruttenberg, Mr. Jay H. Selz, Mr. Aaron Siskind, Mr. Sidney J. Taylor, and Ms. Jane Reece Williams. Our sincere thanks to these individuals for their belief in Barbara Crane's work and their support of the Center.

JAMES L. ENYEART
Director

viii

Photographer's Statement

The realization of this book and exhibition has enabled me to analyze what I have done in my work, where I am now, and how very much more I want to explore in the medium of still photography.

I have consistently worked with the dual concepts of abstraction and social documentation. The book has been sequenced to clarify these longtime interests with a selection of images from the various ideas I have explored.

I need to photograph people as affirmatively as I can. That is the way I see people, and by photographing them, I fulfill some of my needs for diverse human contacts.

My more abstract work represents another facet that requires an outlet for intellectual adventure. I have learned while in pursuit of visual concepts that their resolution cannot be accelerated or rushed. My creative thoughts seem to travel slow, indirect routes, not totally chartable or traceable even to myself.

Many of my photographic ideas have grown from chance or accident, both visually and technically, or from a gift of the subject matter itself. I welcome an unaccountable occurrence stemming from combinations of shutter speed, subject changes, technical happenings, my mistakes, and whatever. When such unpredictable pictures appear, I try to harness the visual episode by taking pictures that will allow the new experience to happen with intent. Fortunately, this way of working seems to expand my ideas and to continuously generate new visual experiences.

The following people are but a few of the many people I wish to thank for their support. Closest to my heart are my children, Beth, Jennifer, and Bruce, who have always been understanding of my obsession with photography. I wish to express my appreciation to Jim Enyeart for his longtime belief in my work, for his astute perceptions and knowledgeable guidance in organizing the exhibition and editing the book. I also

wish to acknowledge Ansel Adams, Aaron Siskind, Shelley Rice, and Paul Vanderbilt, who have in past years supported me both as photographer and photography teacher. There is a long list of photographer friends, past students, and assistants whose belief in my work and generous help has aided me in the realization of this book. A few of their names are: Roth Mui, Alan and Victoria Cohen, Luciano Franchi de Alfaro III, Allen Hess, and Nancy Barton.

I also wish to thank the staff members of the Center for Creative Photography for their extraordinary professionalism and enthusiasm in making the whole project a reality.

I am deeply grateful and indebted to the organizations and individuals whose financial assistance made the extent of the book and exhibition possible.

With deep appreciation I thank Dr. Estelle Jussim and Paul Vanderbilt, who have invested hours of interview time, thoroughness of thought, and their talents in the writing of their essays.

BARBARA CRANE

Barbara Crane

Imagination, Phototechnics, and Chance: The Work of Barbara Crane

BY ESTELLE JUSSIM

Her achievement is substantial, her productivity amazing, her prints — from the intriguing *Petites Choses* to the large-scale industrial murals — demonstrate an integrity and continuity of vision coupled with an impressive technical excellence. Her work is not casual, delicately charming, or as demure as her petite physical presence might lead you to expect. She is complex, cerebral, yet sensual in a direct, unabashed way. With an intelligent consciousness of what she is pursuing, she commits herself to the photographic event with boldness and passion. What is so delightful about her work is that it encompasses both high seriousness and a formal playfulness, a sensitivity to the microcosm of found objects transformed into monumental conception, and a rigorous sense of purpose enlightened by devotion to chance and instinct.

Crane is an influential educator, recently elevated to the rank of full professor at the distinguished School of the Art Institute of Chicago, where she has been teaching photography since 1967. Whether as visiting artist or workshop leader, she has attracted students and audiences all over the country — at the Ansel Adams Yosemite Workshop, the School of the Museum of Fine Arts in Boston, the Massachusetts Institute of Technology, the Victor School in Colorado, the Friends of Photography in California, the Philadelphia College of Art, and the International Center of Photography in New York.

She has had one-woman shows at the Museum of Science and Industry in Chicago, the Davis Gallery of Stephens College in Columbia, Missouri, the University of Iowa Museum, the Worcester Museum in Massachusetts, and the Vision Gallery in Boston. Forty-five group exhibitions have included her prints, which have been purchased by George Eastman House, the Library of Congress, the Art Institute of Chicago, the Pasadena Art Museum, Polaroid Corporation, Sam Wagstaff, Arnold Crane (no relation), Rouald Bostrum, David C. Ruttenberg, and other public and private collections.

This retrospective of Barbara Crane's work should be considered only an introduction to selected aspects

1

of an accomplishment that is unusual in its versatility. As editors and curators know all too well, it is a brave and difficult act to cull from an artist's production of thousands of prints only a certain few. It is almost impossible and probably not even desirable to try to designate "the best" out of the context of hundreds of related images. Barbara Crane is one of those many artists of the camera whose work is cumulative, not only in conception but in effect. Included here is a representative selection of some — by no means all — of Crane's major preoccupations, an introduction to only a few of the challenges pursued and conquered, of projects initiated and completed. It is a clear invitation to pursue her work in greater depth.

Barbara Crane conceptualizes in all formats, shapes, and sizes and is now making an extensive exploration of color, an activity for which her Guggenheim Fellowship was awarded in 1979. This is by no means the first time that she has given herself wholeheartedly to a project that requires mastering a new technology. In fact, despite her claim to dislike hardware, it is at the core of her self-knowledge to have recognized exactly how "any given piece of equipment strongly influences image concept." Typically, she rejoices in the opportunities and challenges of new phototechnics and will modify, experiment with, and push to its extremes any instrument or material that has excited her imagination. The origins of such energy, commitment, and daring are surely embedded in a unique psychodrama, the outlines of which can only be tentatively sketched here.

Born Barbara Dell Bachmann in Chicago on March 19, 1928, she was brought up to be safely bland and taught to survive a rigidly anti-Semitic neighborhood by her upper-middle-class, German-Jewish parents. At stiffly upper-crust New Trier High School, she was encouraged by her peers to masquerade as just another emotionless "nice girl." Ruled by a formidable Teutonic discipline in a competitive family situation not noted for its calm, she developed perhaps too many internal restraints. Typically, it was only in her photog-raphy that the cap could come off the bottled-up emotions, and that release would take years to accomplish.

Her earliest memories of photography are of her father in his amateur darkroom, printing his negatives of family and friends. Crane was then a teenager, and it was a magical experience watching her father make a great game out of the mysteries of printing. Each time a print developed in its chemical bath, it seemed a victory for light and definition over emptiness and obscurity. She thoroughly enjoyed these quiet, good-humored moments.

After the war ended in 1945, she went off to Mills College in Oakland, California. "It was the best thing that could have happened to me," she observes. Mills was not only a superb liberal arts school, it was a women's college. Up to that point, she conformed to the societal pressure which had been teaching her, "All women are dabblers and dilettantes." That was her first real challenge: not to be a dabbler. It was depressing enough that her family thought art was an extravagance and marriage the only career for a woman. At Mills College, she found her first female role models of a more encouraging kind, among them the great American photographer Imogen Cunningham. Later, Crane and Cunningham became friends, maintaining contact until Cunningham's death in 1978. Of her, Crane says, "She gave me such hope; she gave me the sense that one could survive."

Majoring in art history, she had a project that required photocopying paintings. Her first camera was a 1947 twin-lens Kodak Reflex, which she traded in three years later for a Rolleiflex. A design instructor obligingly provided about six hours of practice in developing and printing. More importantly, he put into her hands the works of Gyorgy Kepes and László Moholy-Nagy, then the guiding geniuses of the Institute of Design in Chicago. Moholy-Nagy had been a leader of the European Bauhaus and had transplanted to Chicago the ideals and methods of the avant-garde formalists and modern functionalists. Kepes had recently published his influential *Language of Vision*

(1944), in which he proselytized an art based on "the shaping of sensory impressions into unified organic wholes."[1] This was to be an art of discovery, an art of experimentation with materials and form, rather than the copying of nature. The goal of the modern artist was to pursue "the closest connection between art, science, and technology."[2] Early exposure to these Bauhaus ideas of the connection between technics and aesthetics undoubtedly laid some of the foundations of Crane's later approach to her art.

Photography swiftly became an obsession, but as she tells it now, it was 1948, a time when "you lost your boyfriend if you wielded a camera, so photography had to be a very private affair." She was coming of age in a generation that taught women to be submissive, self-effacing, and "feminine" — meaning totally consumed by maternity, *Good Housekeeping* ads, husband, home, and "togetherness" — one of the slogans of the time. In 1948, before she could finish at Mills, she was hurried into marrying Alan Crane, who promptly moved his new wife to New York City. There, with her husband's approval, she worked at Bloomingdale's in the portrait studio, her first professional experience in photography.

Manhattan was stupendous. She haunted the Museum of Modern Art, overwhelmed by Mondrian, Matisse, Klee, and photographs of architecture. In 1950 she completed her B.A. at New York University with a senior project comparing three New York churches with their European counterparts. Architecture has remained a perennial interest, but there were many other attractions in New York. She recalls that the Guggenheim Museum was still in a brownstone when she avidly pursued their programs of abstract and experimental films. Often she went alone to the dance performances of Ruth St. Denis and José Limón, continuing an interest encouraged by many friends at Mills who had been dancers and musicians. She was beginning to be tantalized by the notion that there were connections between serial music and visual art. A memorable class in oriental art, taught by a Metropolitan Museum of Art curator, introduced her to the triptychs, folding screens, scrolls, and calligraphy, which embody many of the non-representational, formal aspects admired in Kepes's *Language of Vision.*

In 1952 the Cranes moved back to Chicago, and in the process of moving, "The enlarger was packed up," and it stayed packed until 1960. She had been programmed to be a good mother: for eight years she denied herself photography while she devoted herself exclusively to her three young children. But once the youngest was safely in pre-kindergarten, out came the camera, the enlarger, and the trays, and daughter Beth's bedroom became a darkroom. For a few years, she free-lanced as a photographer of other people's children. Then, by a stroke of good luck, one of her subject's parents directly intervened. His public relations firm wanted someone to take portraits of the corporate giants who ran Chicago's newest industrial park, and he enthusiastically recommended Crane for the project.

In the early 1960s businessmen apparently found it unusual for a woman to be taking industrial portraits. Petite and seemingly fragile, Crane was careful always to dress in conservative, tailored suits and to smile at patronizing remarks. As a model for independence, she kept Ayn Rand's architect hero of *The Fountainhead* very much in mind. But even if she was also reading Betty Friedan by then, she still imagined that she was fighting only Barbara Crane's battles, not experiencing a typical woman-in-business situation. The recognition that it was perfectly legitimate for a woman to seek employment that would help her realize her own worth as a person slowly emerged.

By this time, she knew that her marriage was in serious trouble because of a fundamental clash of temperaments. Despite valiant efforts, the marriage lasted only until 1965. Its dissolution, however painful, completed an artistic liberation that had been evolving since 1960.

In January of 1964 she brought a portfolio of her prints to Aaron Siskind, then teaching at the Institute

of Design at the Illinois Institute of Technology, the former home of her earlier idols, Kepes and Moholy-Nagy. Siskind was an inevitable choice. He seemed the only photographer in Chicago who would understand and sympathize with her preoccupations with experiment and form. She was desperate to find other photographers who were on the same frequency, who wanted to create images of consequence and monumentality. Siskind was generous with his time and frank with his opinion: she had to go back to school, this time into studio classes. That seemed an impossible idea, yet she called him the very next day to ask how she could register for courses with him. She then put herself through the graduate program at the Institute of Design with portrait commissions. Six months after enrolling in the program, she landed a job teaching photography at her old alma mater, New Trier High School

The Institute proved anything but easy. She was self-conscious about being both suburban and a mother. The divorce had granted her custody of three children who still needed her. Since their care precluded having the freedom to take street pictures, she paid her children thirty-five cents an hour to model for her — not the first time a woman photographer has had to make a similar compromise. They were often posed on the basement ping-pong table, and they complained they did not want to be recognized in her pictures. The solution was to find ingenious ways of making compositions without including their faces. For her Institute thesis, a production of ninety images of the human form, she did occasionally manage to hire professional models in addition to her children. For inspiration for some of these, she turned to Modigliani's nudes and Matisse's sinuous line, wanting, as she says, "to see if I could produce something like a contour drawing in clean black lines having the energy of a sketch and the sensuality and ambiguity of a Matisse calligraphic ink drawing."

Between 1964 and 1967, Crane taught at New Trier, where she initiated a dynamic program. In 1967 she presented a slide-lecture on her students' work at the annual meeting of the Society for Photographic Education. Immediately, Ken Josephson, Harold Allen, and Frank Barsotti all invited her to teach at the School of the Art Institute of Chicago. But other well-known photographic instructors were not so pleased by her presentation. They were offended and upset that she did not consider good composition as merely the underlying structure of a social message but rather as a formal examination of relationships for their own sake. The documentarians and adherents of "straight" photography were unhappy, while the poets of the camera, like Todd Walker, were so impressed that they borrowed her slides to show at their own institutions.

If she had been a pioneering teacher at the secondary school level, she now found herself enmeshed in the politics of photography. That politics rises out of allegiances as arbitrary as our national two-party system, and the most recent articulation of the ideological issues was John Szarkowski's exhibition, *Mirrors and Windows: American Photography since 1960,* at the Museum of Modern Art, 1978. Szarkowski is undeniably one of the greatest critics of photography, yet the dichotomy perpetuated by that exhibition has only served to exacerbate the ideological excesses of both sides. While Szarkowski modified his original conception by claiming that his intention was not to divide photography into two parts, but rather "to suggest a continuum, a single axis with two poles"[3] and that all photographs were part of a "single, complex plastic tradition,"[4] it was obvious that he did make a distinction between two notions of what a photograph might be: "Is it a mirror, reflecting a portrait of the artist who made it, or a window, through which one might better know the world?"[5]

To understand Barbara Crane's position within photographic politics, we should recognize that her work falls into both of Szarkowski's arbitrary categories. But an implicit value judgment is laid against the "mirror" artist. Szarkowski implies that "window" artists help us *better* to know the world. Yet Immanuel Kant demonstrated that we can never know the world apart

from the inherent limitations of the human brain and the strictures of pre-established mental and cultural concepts. Advanced scientists admit that complete objectivity is a glorified myth. Intuition and poetic metaphor teach us as surely as Comte's formidable statistics, only they may teach us about different events. I cannot imagine that Szarkowski meant to deny the human insights of diarists like Virginia Woolf, Jean-Jacques Rousseau, or James Boswell, nor the subtle psychological portraits by the great novelists. The more we are forced to pretend that we are investigating the phenomenological world without benefit of emotion, the more we approximate the stereotype of the "mad scientist." The "mad scientist" is mad because he has lost his sense of human values. It is not at all a question of "mirrors" or "windows" but rather the much more perplexing issue of what we plan to do with our knowledge, acquired by whatever means. The "mirror" artist is often trying to move us to action; the "window" artist may simply be offering vacuous description.

To a surprising extent, approaches in photographic criticism, journalistic enterprises, even entire schools of the art, are mired in a century-old argument over whether photography is (or should be) a science or an art, or whether manipulated photography is as legitimate as "straight." Some curators, educators, and critics of photography contend that photography cannot be abstract, must not be formalist, dare not be "decorative" — that now fashionable word, which was all too recently a term of execration. Yet Aaron Siskind, Paul Caponigro, Imogen Cunningham, Minor White, Ken Josephson, Barbara Crane, and a host of other photographers have created an imposing body of work no less respectable than that of Robert Frank, Garry Winogrand, Tod Papageorge, Diane Arbus, Lee Friedlander, and William Eggleston, to mention only a few.

What is particularly interesting about the career of Barbara Crane is that she has always felt the pull of these antipodes on a personal level. She has deliberately alternated between intensive explorations of visual phenomena structured into complex designs and an approach that relies on chance as connection with unpredictable humanity. At times she has found the immersion in purely formal and impersonal visual stimuli so exhausting that she has had to pull back to a more simple relationship with strangers interacting in relatively chaotic environments like beaches and parks. To give chance its opportunity is her personal ideal, even in her more structured work. For the structured work often manipulates found objects or chance juxtapositions, subjects she has accidentally discovered have the same kind of visual vibration, something she likens to the tensions in Futurist paintings.

"To give chance its opportunity": late in the 1950s, Crane became a devotee of John Cage and Merce Cunningham, the composer and choreographer whose aleatory theatre and music compositions were so controversial at the time. Yvonne Rainer has called their improvisational, yet structured, work "spontaneous determination."[6] The method of aleatory art in any medium is to select several formal motives, place them in sequence without predetermining their combinations, and then perform them in a spirit of spontaneous discovery within the limits of a given time and/or space.

Crane's sequences, like the People of the North Portal series, are deliberate explorations of combinations of motives, carefully predetermined. As she has explained, "Chance extends the boundaries of my imagination. I try to set up a framework to allow this to happen: I choose where I stand; I determine the tonalities; I select the forms; I look for the right light. Then I give chance a little room to perform for me."

This delight in chance led, for example, to the series of pigeon pictures that Crane used as part of the collage in the enormous bank mural called *Chicago Epic*. Crane was flat on her back on the ground, with the camera pointing directly to the sky. Her assistant then poured pigeon feed all around her, stepped back until the pigeons came in to feed, and then rushed in to scatter them in a flapping of blurred wings. Crane

shot three exposures per scattering. The interplay between seed, feeding, rushing, scattering, and snapping must have been amusing to spectators, many of whom may have thought Crane was completely mad. But Barbara has never been afraid of risking public disapproval for the sake of capturing new and difficult images. She has trudged through the streets of Chicago pulling a golf cart burdened with a 5 x 7 camera, tripod, film holders, lenses, and other materials. She has placed herself forthrightly with her heavy press camera in the midst of hectic beach scenes. With good humor, she recognizes that she was many times in danger of being trampled, perhaps most especially during her shooting of Commuter Discourse and the North Portal series.

While chance has always been given its opportunity, Crane has invariably selected the motives for the performance. In one of the earliest series of multiples, *Neon,* she was using double exposure. The film already had on it the reflected lights of giant electric signs. The patterning of light bulbs perforates the superimposed faces with a "do not fold, spindle, or mutilate" effect. The delightful *Neon Cowboy,* with its luminescent outlines vibrating against a background of nudes, was the forerunner of experiments with combining different sizes into one print. An impetus toward this kind of combination image was the purchase of an old 8 x 10 enlarger that offered the potential of printing two 4 x 5s side by side in a dialogue between two images. This, in turn, led to the notion of creating one 8 x 10 print from whole rolls of 35mm film and of playing with combinations of sizes and shapes printed together. She had long before calmly sawed sections out of the wooden slides of her Deardorff camera to permit multiple exposures on one negative.

In the Wrightsville Beach series, Crane says she began to think of the implications of the space beyond the edges of a particular image format. She wanted to encourage the viewer to see the rows of similar yet different houses as a kind of infinite progression. The houses were so ubiquitously alike as to preclude the notion of individuality. Yet within this Mondrianesque beat, the unique individuals who inhabit these beach houses or who work in this repetitious environment staunchly display their stubborn idiosyncracies. Crane provides an enjoyable tension between anonymity and personality.

The Whole Roll series begins with a shocker pulsing with an obscene rhythm. It is as if a disease of pornographic amoeba was about to explode from the paper. The circular shapes are not Frank Mouris-like fantasies, however, but simply variations on intertwined human forms. The round pictures were obtained by using a lens shade too small for the lens surface. The row boats in the Whole Roll series share with *Neon Cowboy* an iridescence and sparkle determined by sharp contrasts of light and dark. Like the Op Art of the 1960s that helped give birth to these repeats, the rowboats seem first to be structured in an overall pattern; then they seem less like boats and more like flat bullet-shaped cutouts turning on rows of wires, and finally they vibrate like the crazy gaudy streamers at second-hand auto dealers.

I find distinct correlations between several aspects of Crane's work and the paintings of Op Art. As Cyril Barrett observes, optical effects created by the repetition of anonymous forms were the essence of the 1960s Op Art movement, in which Victor Vasarely, Bridget Riley, Josef Albers — another Bauhaus leader transplanted to the United States — Dieter Hacker, and Francois Morellet figure prominently. The fact that Albers can be placed within the Op Art tradition as well as in the Bauhaus ideology is confirmation of the connections between the two movements and suggests a similar development within Crane's photography.

Op artists rejoiced in aleatoric combinations as well as in the spontaneous determinism that marked Cage's and Cunningham's dance pieces. Like these two performers, Crane has always been fascinated by the element of time as an aspect of picture-making. Barrett believes that Op Art was the first conscious manipulation of the element of time within pictures.

"Instead of building up a set of relationships between elements which can be apprehended more or less simultaneously, it permits the artist to relate visual experiences in a temporal sequence. It has the added advantage that he can work with simple elements; the richness and complexity lies in the possibilities for development rather than their structure at any given time. . . . This in turn permits the element of indeterminacy and randomness."[7]

The Whole Roll series and her large murals share with Op Art the reliance upon abstraction, hard-edged geometry, a keen sense of scale, and the manipulation of anonymous forms creating a vivid optical effect.

In her Combines, Crane utilizes the principle of synechdoche, the part for the whole: an exploding center image is explicated by the repetition of similar tree gestures below. Analogous shapes dominate this series. A found pigeon's wing and a discovered tree are seen in the eerie light of negative printing: the frame on each side of the parade of tree forms is cut through the middle, so the left frame reveals the right side of the tree and the right frame reveals the left. These tensions create two diagonal pulls through the fan shape of the feathers.

Crane has been collecting found objects for more than ten years. They have stimulated concepts dealing with recycling, randomness, open-endedness, and infinity. In *Phantom Image #1* (20" x 24") a found object like the shadow of a blurred animal races through an overall pattern of dappled light, an assemblage of thirty frames carefully selected. The illusion is uncannily like looking down at the fleeting shape as if the viewer were on horseback. The stone blocks of *Phantom Image #2,* a montage of thirty-six frames, some of them cropped along the outer edges of the composition, support the shredded branch shapes to create an ancient graffiti on an implacable wall. One of her comments about this series is that she was showing big prints when the fashion was for small, but this pioneering in the large print paid off handsomely in her first major industrial commission in 1975–1976.

Her monumental prints, with their combines, repeats, optical effects, and analogous shapes found their perfect expression in the sumptuous mural series for the Baxter/Travenol Laboratories Corporate Headquarters in Deerfield, Illinois. Her commission was to execute twenty-four murals utilizing Baxter's medical products as subjects. They were stunned by what they received: gigantic, heraldic combines in which medical paraphernalia were structured into striking decorative patterns. Within some formal patterns was a large centerpiece containing recognizable and often humorous human actions. *Just Married, Bus People, Victorian Assembly, Suspended Boardwalk,* and *Bicentennial Polka* can probably only be appreciated *in situ.* They lose much of their tremendous decorative impact reduced to book-size. In fact, much of Crane's work suffers more than most from loss of scale of the original in reproduction.

Yet even in reproduction, one can feel the vigor of Crane's imagination through photographs of the murals on site and in scale with walls and furniture. The Baxter murals rely heavily upon analogy or what she calls "similar sensibilities" in differing subjects. *Bicentennial Polka* makes the most obvious use of the similarities of diagonals. Crane picks up the rhythm of the sailors' movements forward, the spaces between them, the shapes of their legs, and the intricate triangles produced by their gestures, and ricochets these off the march of the test tubes. It is heraldic, humorous, and human. *Suspended Boardwalk* floats on a grid of four black verticals, suspended like a billboard sign on a writhing floral decoration composed of dialysis cables. The energy of these repeated units propels two vacationers through their tilting landscape.

In the ingenious superimposition of *Just Married,* the cloud shapes form Rorschach patterns, while the doubling of the Baxter water tower, by inversion, converts it into a repeated surreal hourglass. The frontal plane of the mural seems carved and emblazoned like a mannerist bas-relief in which the absurd one-point perspective of the cars, the scrawled "Just Married,"

and the floating real sky clouds produce a marvelous visual ambivalence. *Victorian Assembly* is the most optically misleading of all: the abstractions of the repeated isosceles triangles prove to be women seated at infinitely retreating assembly lines. This of all the Baxter murals is the most quilt-like and reminds us that women have long been noted for their outstanding contributions to the arts of weaving and textile decoration.

Indeed, in one of the murals her fascination with the *trompe l'oeil* possibilities of scale and distance creates from granite boulders and waterfall sequences a striking overall pattern rather like a modern tapestry; yet, in close-up, each image reveals all the expected reality textures of the landscapes photographed. The duality of this activity is one of the visual excitements of Crane's work in this style. Another *trompe l'oeil* mural contains matched inverted sets of abstractions created by the serpentine curves of under and overpasses on a highway. Out of these dark and light contrasts evolves an overall gyration of giant butterfly shapes. With the people at the top and the sight-seeing bus at the bottom, *Bus People* offers simultaneously a dynamic design of intrinsic visual interest and a metaphor of road travel.

In all these murals, she creates movement without copying movement, just as Op artists do, and as they do, she delights in altering scale. Paul Vanderbilt once gave her a tiny bit of lace: this ribbon finds itself enlarged to the size of a Toltec snake crawling across a surface of lace-like analogies. *Tar Findings* is yet another example of Crane's obsession with shape, form, and texture translated into large-scale icons. Here the push-pull of the micro and macro worlds creates a tension not unlike the surreal floating forms of Yves Tanguy and Joan Miró. Viewed up close, these "findings" — some of them originally the size of a small fingernail — have the odd texture of elephant skin. They resemble not so much minute drippings of roof tar but peculiar creatures floating in a microscopic slide. In mural size, the tar drippings have much more

than visual impact. The textures and shapes are so compelling that we are forced to "touch" them with our eyes.

In the Albanian soccer players combine, with its very precise selection of inverted images conning the eye into thinking of reflections, we can find a resemblance to the all-over perspective of Eskimo carvings. The Eskimo do not hesitate to carve in all directions, as the Innuit view of reality is non-linear and interpenetrating. Crane asks us to share this view.

The *Petites Choses* series crashes down from the monumentality of the Baxter murals to the intimacy of images smaller than one's hand. With these repetitions you may begin to ask, "What if yet another one or two units of the design were added, would the effect be substantially altered?" Yes. The units are strictly calculated as to number. But, in fact, not all the *Petites Choses* are exact repeats. With the marvelous close-ups of the eye of a steer, we enter a much more ambivalent realm. Like many of Crane's early experiments with human form, the ambiguity here is deliberate and shocking.

The next group, Repeats, offers a Swiss Alps sequence labeled *Crust,* and here the ambiguity ranges from the inversion of forms to metaphors about crustiness resembling good French bread or the jaggedness of a snake shedding its skin. *Dan Ryan Expressway II* slices reality into an hypnotic pattern, which creates out of still pictures the surprising reminder of those interrupted and often unintelligible glimpses we see out of the windows of speeding buses or trucks. Of the Repeats, the most sensual and surreal is the series of the boy's hand being licked by a steer's tongue. It has an overtone of unexpected perverseness. The visual oddity depends on the contrast of black background with white arm: it is an arm removed from the person, acting independently and therefore vulnerable. *Zag Zig* is also hypnotic. Lace, fire-escapes, and calligraphic graffiti all join in a syncopation of wiry forms, greatly reminiscent of the notes and pen squiggles Crane makes at concerts.

The People of the North Portal series was over a year in the making and should be considered an aggregate of images rather than single pictures to be judged by those arbitrary standards of composition or content traditionally applied. In 1970 and 1971, Crane decided to attempt "a documentary out of which people can draw their own facts," a continuous investigation of visual cues about strangers in a specific setting. The North Portal, a doorway on the north side of the Museum of Science and Industry in Chicago, was to serve as a stage and as a visual constant. Using aleatory principles, she selected the combinations of phototechnics and environmental motives she would use. Changing lenses from day to day, she concentrated now on edges, now on close-ups; on some days she opened the two doors, on others she left one door open or shut them both, so that the people exiting from the museum would have a variety of options for pushing, moving, or walking. For the close-ups, Barbara walked through the doors each time, passing her subjects with the camera focused at twenty-one inches. Here she notes an advantage to being short: the men looked down into the camera and the kids were at her eye-level.

The difference between the near/far images results from her use of lenses of various focal lengths while standing braced against a column about twelve feet from the doorway. Eliminating the coldest of the winter months, during which Chicago is blasted with icy winds or knee-deep in snow, Crane shot a minimum of twenty-five 4 x 5s each day, with a total of 1500 shots in this series. She wanted a kind of *Comédie Humaine.* At first she rejected the clowns who hammed it up for her, but later she realized that these actions were as valid a part of her scenario as those oblivious to the presence of the photographer.

The North Portal series has been her most controversial work. Angry critics have suggested that she could have simply put an automatic camera in front of the portal and left it there to take pictures at set intervals. But Crane protests that every picture represents deliberate choice: in the placement of the subject, in the options of open/half-open/shut doors, where she was focused regardless of the length of the lens so that she always knew where a subject would land, and so on. Each day offered a choice between potential interactions of people, since she would give one day to shooting only couples, then foursomes, then only women together. She was always relating the activity at the edges of the picture with the central activity and always sought the same kind of "layering" effect with people as she would shortly use with architecture. She harnessed the unexpected, made distinct editing choices. She did decide to border these pictures in black, perhaps the least successful aspect of these otherwise striking images. Generally, one suspects that the virulence of some critics' objections really arose from their ideological rejection of chance as an element of art, making Crane by no means a unique object of misunderstanding and rejection. We must remember that even so great a master of the "chance witness" photograph as Garry Winogrand has been excoriated for his approach to picture-making.

In that respect, it is surely surprising that one of the most respected camera workers of our era, Ansel Adams, himself the very model of artistic choice and precise preparation for compositional perfection — in other words, the antithesis of the aleatory artist — has proved one of Barbara Crane's staunchest supporters. Not only has he purchased her work, but he has invited her repeatedly to teach at his own workshop at Yosemite. Adams has encouraged Crane since their first meeting in 1968, and has commented most appreciatively on her vitality and the excitement she brings to students. Ansel Adams is the rare example of a photographer who has risen above arbitrary and limited ideologies of photography, and Crane has greatly benefited from his friendship and constancy.

Between 1972 and 1979, Crane worked for the Chicago Commission on Historic and Architectural Landmarks as a part-time photographer with a yearly contract. She had long been proficient in straight black-

and-white photography, and the director of the project was seeking someone who would be compatible. Crane remarks, "This is true of all photographic jobs. It isn't just what you are as a photographer, but whether people feel they can get along with you." No prima donna, Crane's relation with the Commission ended only when she felt she could learn no more from continuing that kind of work. But perhaps it was inevitable that the architectural commission would now lead into a new, much freer experimentation with form.

The city walls series, now called Chicago Loop series, came after she produced a giant mural for the Chicago Bank of Commerce in the Standard Oil Building. In this twenty-six foot mural printed from a film collage of images of the renowned Chicago landmarks, we find the leaven of the scattering pigeons — eternal proof of the survival of urban fauna. As a reaction to the complexity and hard physical labor of the mural, Crane began to believe she had reached a point where she could only fabricate pictures. To prove to herself that she could still conceptualize and carry out a project of large single-image contact-printed pictures, she gave herself the task of making "design" pictures of city walls, with a center division or mid-horizon line as unifying aesthetic conditions. In these pictures, the skyscrapers loom in militaristic hubris, as Vincent Scully puts it so well, yet they are always compressed by Crane into obedient patterns through which the urban energy emerges. Audaciously, she crops a serpentine front so that the edges of the curving building fool the eye into thinking the print itself is curved. She waits for the decisive moment when just so many window blinds will be open or shut, and wonders what human agency has performed this mystery within a totally anonymous structure. She wonders; but perhaps these photographs do not invite us to do the same. The mind is too rapt in a Chicago Boogie-Woogie.

As the people rush with the buses toward unstated destinations, they are eclipsed by bridges and build-ings. The sky thrusting down between the giant edifices resembles a sharply clipped hole in a dense cloth. The cross-bars of new construction offer no promises of rosy urban futures, but of more and more congestion, blocking movement, inviting defensive actions like putting your arms in front of your face to protect yourself. It is an odd relief to come to the bizarre fabric rendered by wrecking ball, a facade crumbling as if in an earthquake, with no implication of sorrow or loss. It is a relief that we ourselves can destroy what has begun to resemble an impenetrable concrete prison. In a street scene, two clumsy pylons, one in shadow, one in light, mirror each other but foretell different destinies. They are two blind sentinels brooding over the oblivious pedestrians and the drivers who must obey no-left-turn signs and other imperious dicta. The strong central vertical, so popular with many contemporary photographers, here seems a logical outcome of Crane's continuous experimentation with dualities, especially with half-frame and split images.

Crane insists on a personal and artistic balance between more formalistic enterprises and projects that bring her closer to casual humanity, choreographing the latter according to the laws of chance. Naked flesh, the sunburned leg, the greased arm, the innocent pleasures of dancing to music by portable radio, the beach snapshots, the outlandish outfits, the park pictures radiating a late afternoon self-awareness epitomized by one strong-minded old woman asserting her territory with basketball, picnic jug, purse, shoes, and striped kerchief: but these pictures are not meant to be viewed individually. For Crane, they represent parts of a whole pursued for six years, between 1972 and 1978. The sum was to be greater than the individual pictures, and that expectation raises specific critical problems.

How are we to judge the Chicago Beaches and Parks series? Or any series like it, by any photographer? Are they pure storytelling? Conscientious social documentary? *Just* chance? Romanticizing invasions of private lives? Take, for example, the image of the

glassy-eyed blonde with long hair who sits on the park grass, legs outstretched, arms forming a strong V over her knees. Beside her are two children looking off in the opposite direction. On the next plane, an elderly couple seems tied to the earth by long shadows, which also cool their resting dog. Beyond, another couple walks out of the picture carrying picnic paraphernalia, and still other couples and singles dot the remote landscape. *La Grande Jatte* by Seurat, with a dash of Cartier-Bresson? A can of Coca-Cola juts up beside the blonde. It holds the picture together like a beacon: a symbol of popular culture or simply a strong chunk of verticality exactly where it was needed? This is perhaps the best of the park pictures; it has all the solidity and serenity of a Courbet.

These pictures at beaches and parks were accomplished through the social prestige of the press camera. It somehow persuaded her potential subjects that she was no Peeping Tom, no intruder, but a legitimate newspaper or city photographer recording Sunday activities. As we all know, the press camera viewfinder is hardly a precise instrument. Crane finds this an advantage, another opportunity for chance to keep the picture "loose and lively." This feeling of spontaneity, she believed, would help achieve a positive, life-affirming mood.

When Crane cuts in close to her beach figures, she achieves a welcome note of intimacy, an antidote to her urban *angst* of the skyscrapers. Her two dancing Hispanics interlock their negative/positive shapes with the precision of a jig-saw puzzle, but with beautiful tactility. The naked belly exudes both energy and relaxed pleasure. Most poignant of these pictures is an evocative Hispanic trio, mother squashed within the father's embrace, while their long-haired child plays with pebbles on a bleak wall. Far off looms the ghostly silhouette of a harbor beacon on a triangular support, obscured by haze. The painful isolation of this trio is both social and emotional.

One or two of these beach and park pictures verge on sociological cliché, as in the shaved-headed black man with the mod glasses staring at a white woman's white bikini. The cliché is of subject, not of formal expressiveness. And the harshness of this scene is offset by the tender interplay of another black man serenading his sweetheart on his guitar while she suns her naked white back.

Headless, garish, a monumental, one-armed kitsch goddess in a satin black bathing suit concludes this series. Who sculpted this cropped ruin of a body? And is the descending hand hers or a return of the omnipotent hand descending from the top of the opening frames in Maya Deren's *Meshes of the Afternoon?* Even as Crane seeks intimacy here at the beaches, relief from preoccupation with form, her formal sense is so powerful that it sometimes creates surreal monsters. If you stare too long at the black arches of the bathing suit as it carves out the woman's legs, then at the super-reality of the hand's nail polish and bulging veins, you may feel as if this kitsch goddess is ominous and eternal, an antique anomaly erected on the beach by reincarnated pagans.

Now the slight photographer plants herself boldly in the midst of the commuter rush in late afternoon, permitting her super-angulon lens — a 21mm on a 35mm camera — to fill the frame with the crush of the on-coming hordes. She is too short to be able to photograph both the shadows on the ground and their faces. What she seeks is some revelation in this surge, and she rapidly discovers that she needs adjoining frames and half-frames to communicate this sun-burst energy. Once again, it is not the individual pictures she desires, but an aggregate, almost a sociological compilation. Sociology might be the best analogy here, for these pictures of the Commuter Discourse deal with the faceless masses and statistics, which are quite different from the social psychological interests of, say, the People of the North Portal. It was the unpremeditated purchase of the lens which inspired the series: she needed a subject that could take maximum advantage of the sun-burst effect, a subject that would give her edge-to-edge forms and suffi-

cient complexity to warrant such great depth of field.

To go from Chicago to Tucson requires considerable readjustment. Not to the new environment of heat and dust. What requires the adjustment is that now Crane is working in a new medium, Polacolor, and she has had a year of support from the Guggenheim Foundation to investigate this color process. She is bold as usual: 8 x 10 Polacolor II is an indoor medium; Crane proposes to use it outdoors. Her first efforts present us with indefinably repulsive shapes, the found objects of her new environment, saguaro "boots," parts of huge cactuses hollowed out by desert birds. The saguaro boots are like cadavers with dessicated flesh, an effect obtained by deliberately overexposing the film to bleach out its normal intensity. Someone gives her a rabbit; it dies, a taxidermist treats it, Crane forces us to see its crucified remains. She is using an ordinary cross-wired fence to hang these objects, automatically assuring herself a decorative unity with both cruel and indifferent connotations. A burnt tree limb, glowing with tar, rests on the fence, a gruesome paleolithic club. Something about the new environment is causing her to see only angry images at first, images unfortunately not illustrated here.

Then she gains mastery of the medium and the color work becomes astonishing. Tucson's searing sun has not obliterated her fascination with found objects. But now these become opportunities not only for formal ideas but for very personal biographical notations. For the first time, perhaps under the influence of the casual southwestern ambience, Crane is permitting herself pure biography. She photographs her own notes to lovers; she worships a flamboyant leather vest. She rises at dawn, however, to pursue the formal exercises of a series of funerary crosses, seeking the pink-rosy colors to match the fading paper flowers.

Another series demonstrates how she has conquered the small Polacolor format. Seen from the back, people move through a country fair, flashing brilliant suspenders, clutching stiff blue overalls and red shirts. The choreography of intimate gestures seems so much more sure and joyous now that she has color to articulate form and rhythm. It is an unusually sure leap from one medium to the next, but of course Crane has been using phototechnics to her advantage all of her career.

In the small Polacolors, she explores touch: hands crossing, a boy's fingers affectionately and possessively tucked into the back pocket of his girlfriend's jeans. A marching band struts away into perfect one-point perspective under a gale of flags. In larger formats, she turns from spontaneous gestures to more formally organized diptychs and triptychs, seeking the pulsing energy that imbued so much of her previous work. She finds her way into the mysteries of nopal and organ-pipe cactus and makes of them both icon and totem. One nopal pod fills the frame, dazzling us with the conversion of its needles into gold or silver dots.

These new experiments with color only verify Barbara Crane's immense versatility, her energy and boldness, her inventive imagination, and her professional expertise, her playfulness and her visual wit. Surprisingly, these attributes have not always served her well in the marketplace, where artists forever discover they are expected to produce only *one* immediately identifiable product. Not surprisingly to those who know Chicago, it has not served her well to be specifically a Chicago artist. For Chicago has the misfortune to be located in a totally imaginary prairie limbo between chic East and mod West, a presumed vacuum where few art critics venture and where a regional paranoia about national neglect is understandably raging. It is a paradox almost beyond comprehension that a glittering metropolis, offering even the most casual visitor stupendous vistas and breathtaking architecture, not to mention several of the world's most significant intellectual and artistic centers, should nevertheless suffer from a gigantic inferiority complex. It appears that wealthy Chicagoans tend to rush to New York or Los Angeles for their patronage of the visual arts, cavalierly ignoring their own immense regional talent.

The term "regionalism" is one of those red flags of criticism which tend to obscure more useful issues. To be sure, there was Chicago jazz, and New Orleans jazz, and New York jazz, but the similarity of these regional musical styles is far greater than their dissimilarity, particularly from the distance of several decades of other, completely different forms like swing, progressive jazz, and rock. So, too, in the visual arts there are certain similarities of coloration, selection of formal elements, and even energies that can be allocated to different regions. Chicago artists can be accused of sharing the same motives of skyscraper and lake, commuter and shopper, city walls and street bustle. They can even be accused of sharing the pervasive influence of the Institute of Design, which not only attracted artists of similar sensibilities but subjected them to the same rigorous training, an education that left its mark on all its adherents. The question of regionalism inevitably raises artificial issues about who did what first, always creating the false assumption that the artists who inhabit a specific region are looking only to each other for inspiration.

Arguments about precedence are impossible to resolve in any case, yet this is an appropriate moment to consider what the aesthetician Morse Peckham calls "cultural convergence."[8] At certain times in history, similar ideas emerge almost simultaneously from different individuals who know nothing of each other's work but who have been exposed to similar intellectual, scientific, technological, and artistic currents. Famous examples are Darwin's theory of evolution, Bell's invention of the telephone, and art movements like Romanticism, Impressionism, and Dadaism. Since there may be no reliable method for distinguishing unconscious influence, educational affinities, or conscious imitation from cultural convergence, the important issue becomes the significance of the images produced, no matter where or by whom.

Certainly, artists cannot be forced to deny their own time and place — even if this were humanly possible. Even Shakespeare can be found to have been embedded in a very Elizabethan theatrical milieu, relying upon previous writers for subject matter and dallying with typically sixteenth-century dramatic conventions. It is the significance of Shakespeare's accomplishments that we judge him by, not by unrealistic notions of total originality. To apply the misnomer of "Chicago artist" to Barbara Crane, in the sense that this implies regionalist limitations, would be a serious condemnation of the politics of photography. As George Kubler observed in his dazzling tour-de-force, *The Shape of Time: Remarks on the History of Things,* "Every important work of art can be regarded both as a historical event and as a hard-won solution to some problem. It is irrelevant now whether the event was original or conventional, accidental or willed . . ."[9]

Crane's ceaselessly experimenting imagination has seized every available means — original or conventional, accidental or willed — to achieve complex, haunting images. Yet, as Kubler also remarks, "history is unfinished business."[10] Her creative and personal history are surely Barbara Crane's "unfinished business," with much still to be performed and much yet to be discovered.

NOTES

1. Gyorgy Kepes. *Language of Vision* (Chicago, Paul Theobald, c1944), p. 15.
2. László Moholy-Nagy. *The New Vision* (New York, Wittenborn, 1947), 4th rev. ed., p. 10.
3. John Szarkowski. *Mirrors and Windows: American Photography since 1960* (New York, Museum of Modern Art, 1978), p. 25.
4. Ibid.
5. Ibid.
6. Quoted in Jill Johnston, "The New American Modern Dance," in Richard Kostelanetz, ed. *The New American Artists* (New York, Horizon, 1965), p. 192.
7. Cyril Barrett. *Op Art* (New York, Viking, 1970), p. 186.
8. Morse Peckham. *Man's Rage for Chaos* (New York, Schocken, 1967), p. 11.
9. George Kubler. *The Shape of Time: Remarks on the History of Things* (New Haven, Yale University Press, c1962), p. 33.
10. Ibid., p. 35.

Early Work

Left: *Carmel, California,* 1948, 11.8 x 11.8 cm Right: *Carmel, California,* 1948, 11.7 x 11.7 cm 15

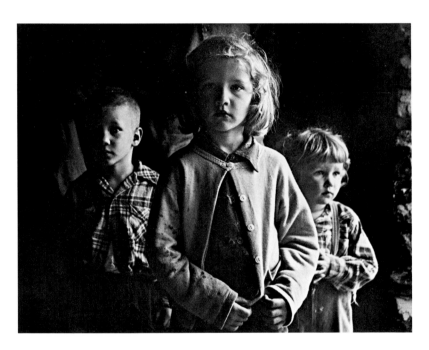

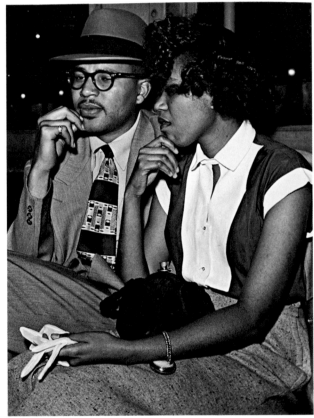

16 Left: *Tanglewood, Massachusetts,* 1949, 19.4 x 24.5 cm Right: *Staten Island Ferry, New York,* 1950, 23.5 x 17.5 cm

Left: *Marvin Cheresh of Sterling Automotive Corporation,* Centex Industrial Park, Elk Grove, Illinois, 1963, 35.2 x 23.3 cm
Right: *Mr. Feingold, Mr. Pape, and Mr. Brinn of Qualitech Corporation,* Centex Industrial Park, Elk Grove, Illinois, 1963, 35.2 x 27.7 cm 17

Human Forms

1964-1969

Human Form, 1965,
23.8 x 19.8 cm

20 *Human Form,* 1965, 20.0 x 24.1 cm

Human Form, 1965, 17.9 x 23.7 cm 21

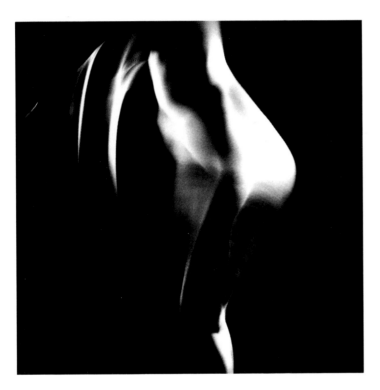 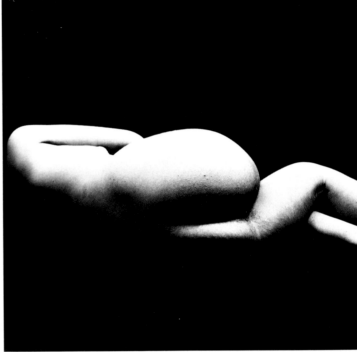

22 Left: *Human Form,* 1965, 19.5 x 18.5 cm Right: *Human Form,* 1965, 19.0 x 19.1 cm

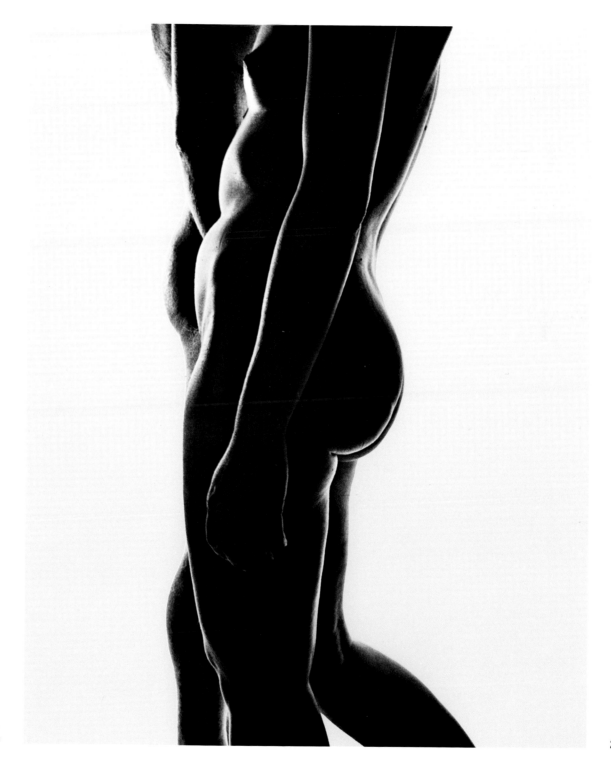

No Tattoo, 1967,
34.9 x 27.2 cm

23

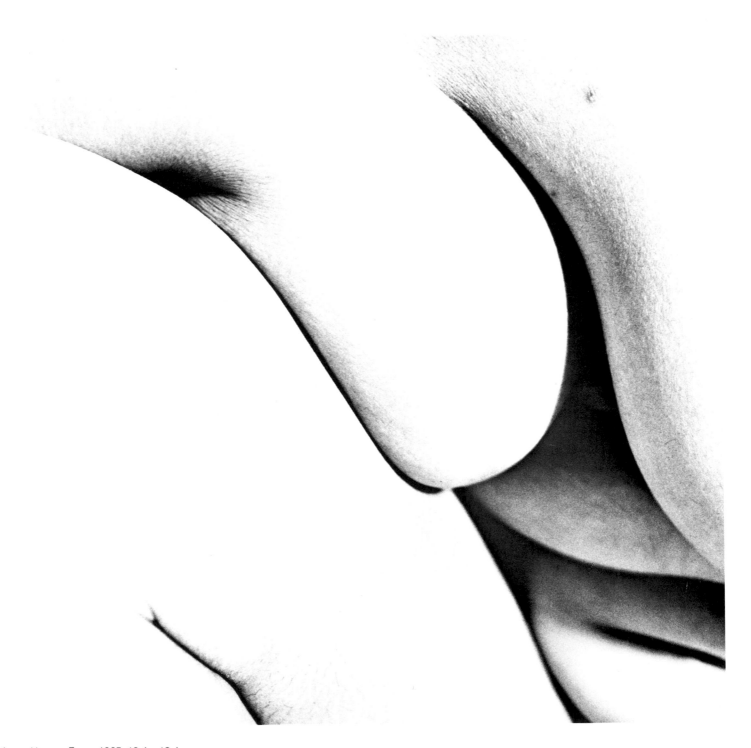

24 *Human Form,* 1965, 19.4 x 19.4 cm

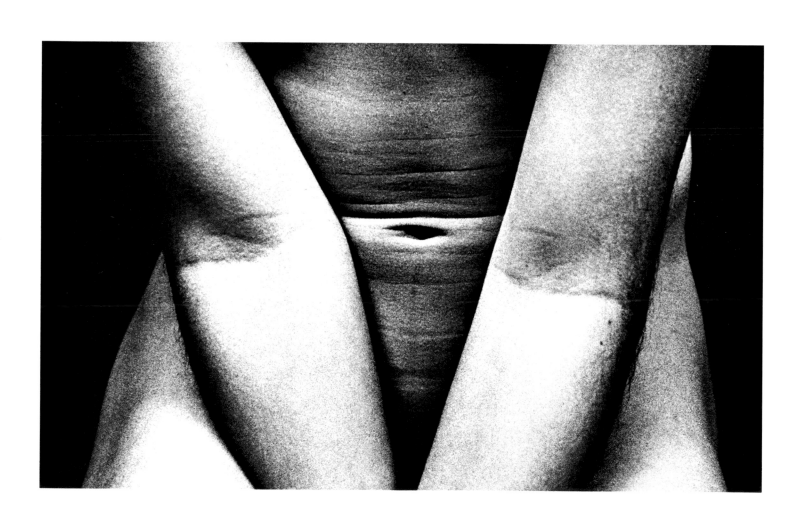

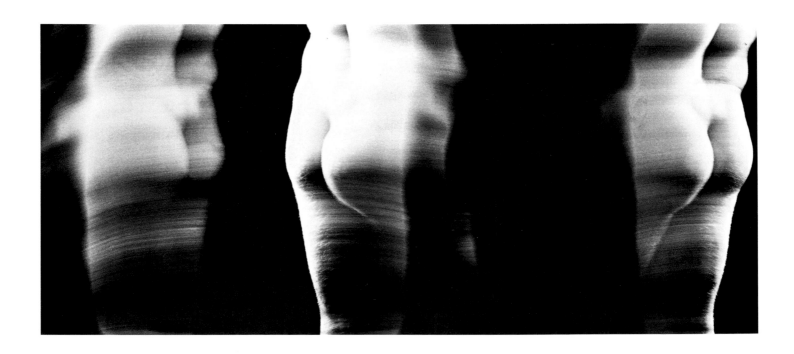

26 *Torso in Movement,* 1965, 16.6 x 35.0 cm

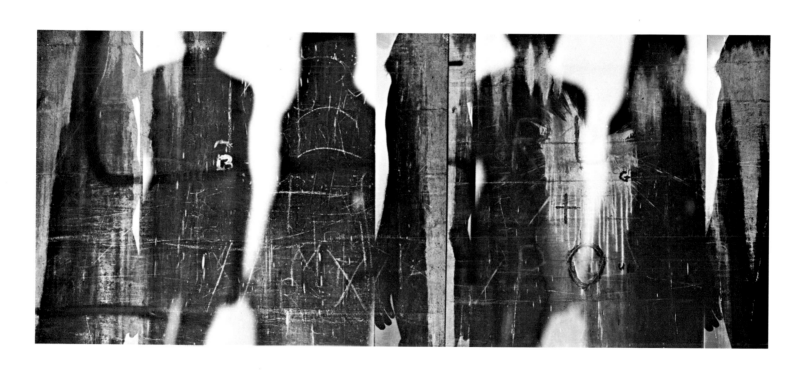

Shadow People, 1968, 15.7 x 35.0 cm　27

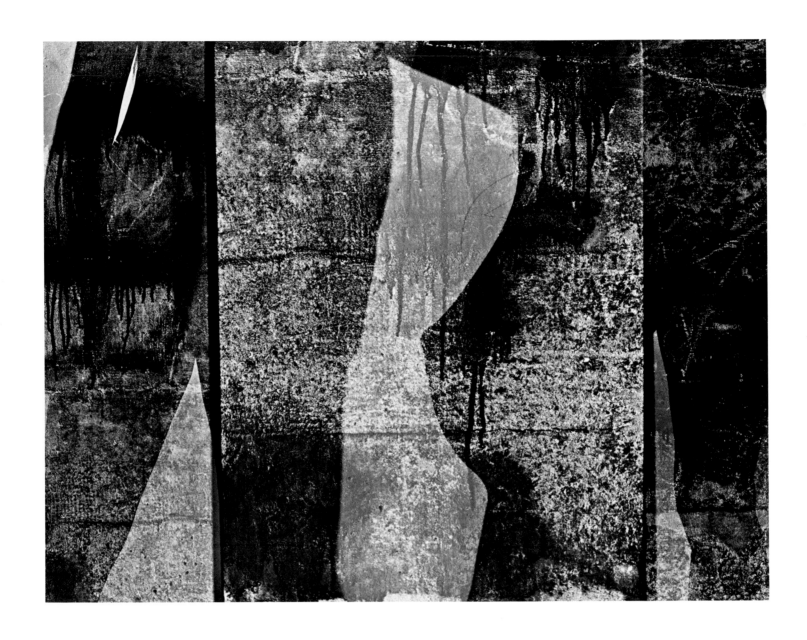

28 *Textured Human Forms,* 1967, 27.5 x 35.0 cm

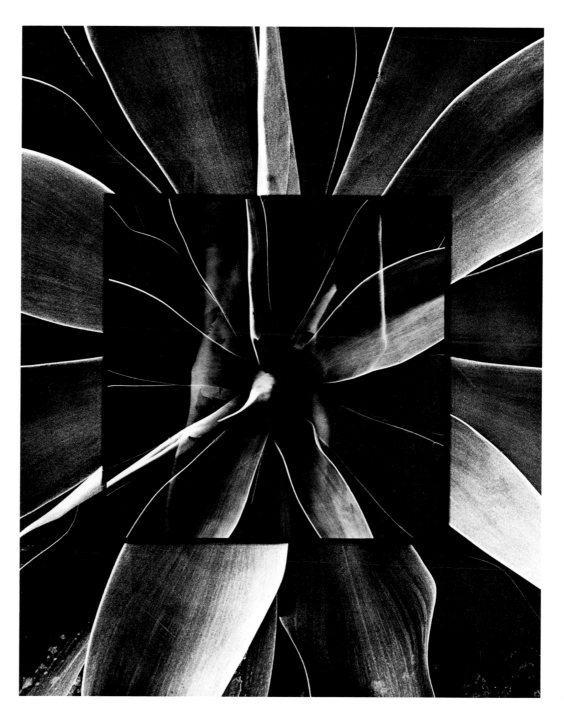

Century-man-plant, 1967,
35.0 x 27.6 cm

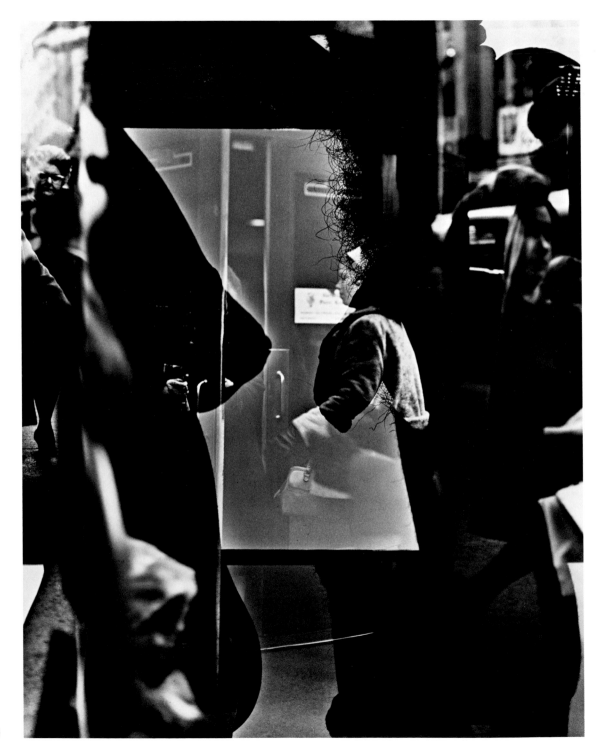

Multiple Human Forms,
1969, 34.8 x 27.3 cm

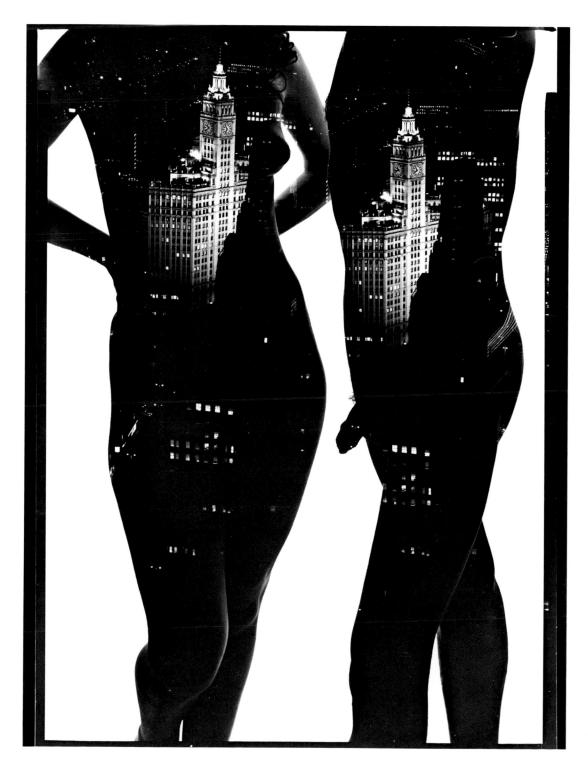

Wrigley People,
1967, 34.0 x 24.1 cm

31

Neon

1969

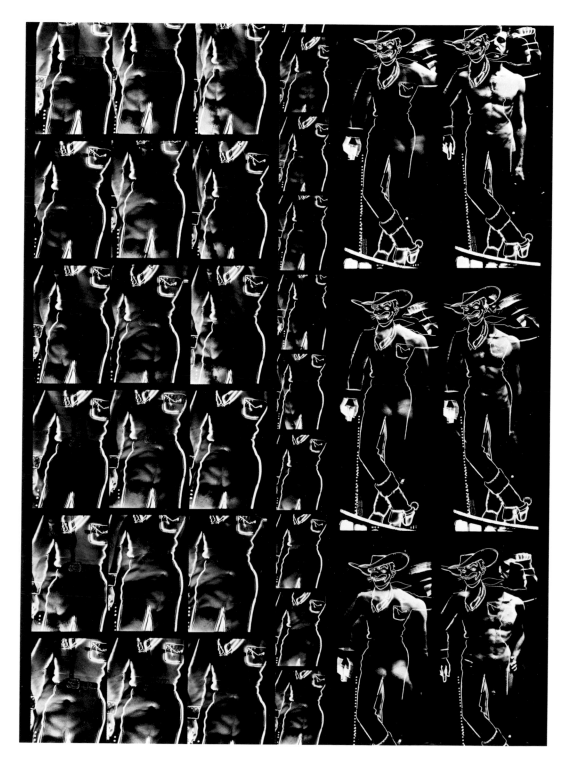

Neon Cowboy, Las Vegas, Nevada,
1969, 34.9 x 27.2 cm

33

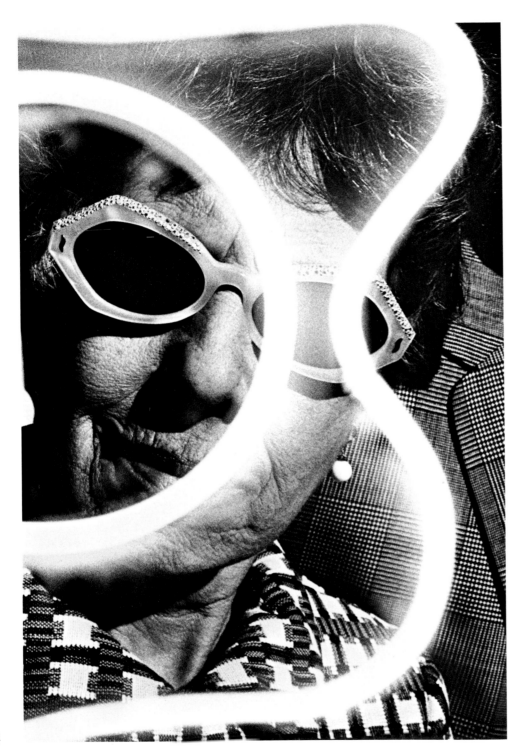

34 Neon series, 1969, 26.3 x 17.8 cm

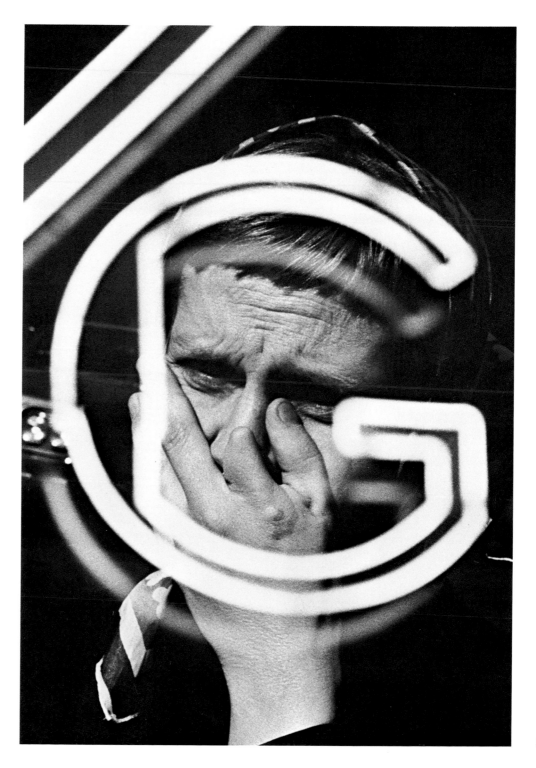

Neon series, 1969, 25.4 x 18.0 cm

35

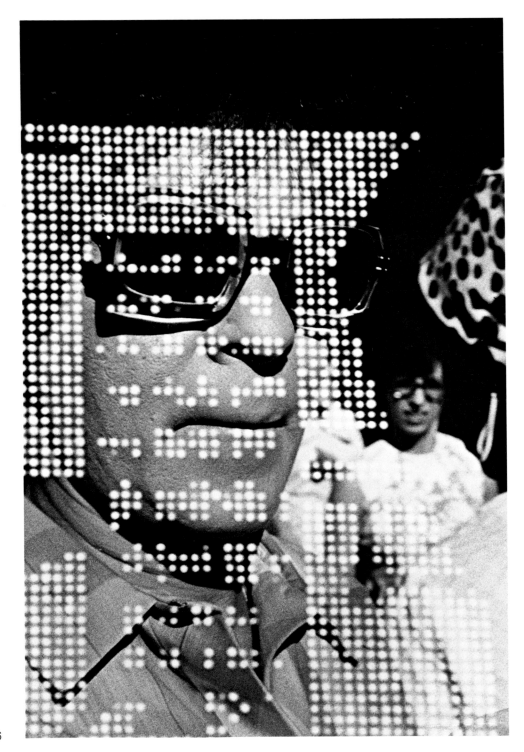

36

Neon series, 1969, 26.1 x 17.8 cm

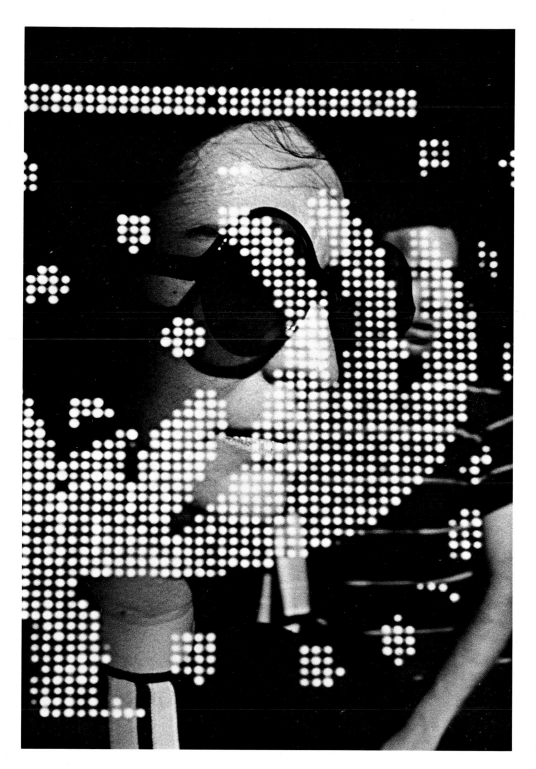

Neon series, 1969, 26.3 x 17.9 cm

Repeats

1974-1979

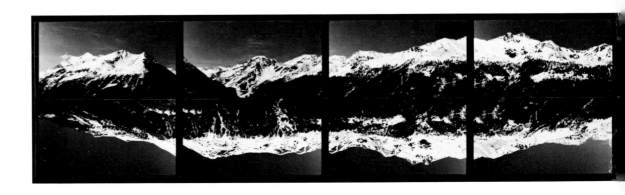

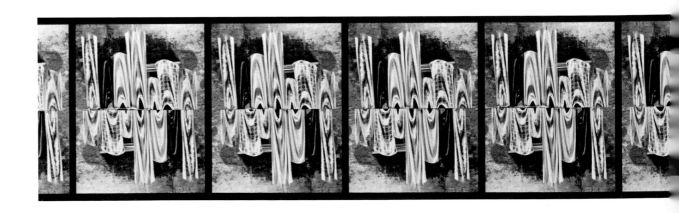

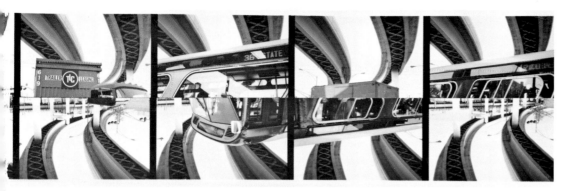

Top: *Dan Ryan Expressway,* Chicago Repeat series, 1975, 10.2 x 50.7 cm

Middle: *The Crust,* St. Luc, Switzerland, 1975, 12.6 x 50.7 cm

Bottom: *Italian Wash I,* Tivoli, Italy, 1975, 4.7 x 21.5 cm

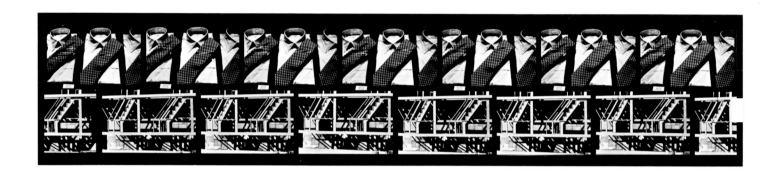

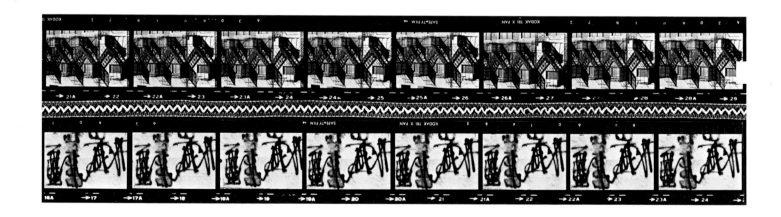

41 Top: *Shirtscape,* Chicago Repeat series, 1974, 13.9 x 35.4 cm Bottom: *Zag Zig,* Chicago Repeat series, 1974, 14.0 x 35.4 cm

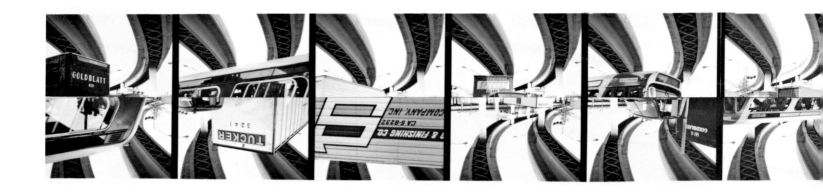

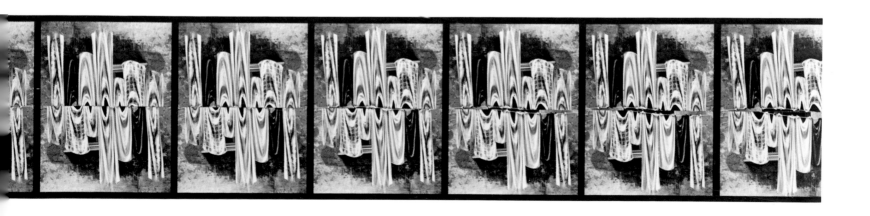

Whole Roll

1968-1978

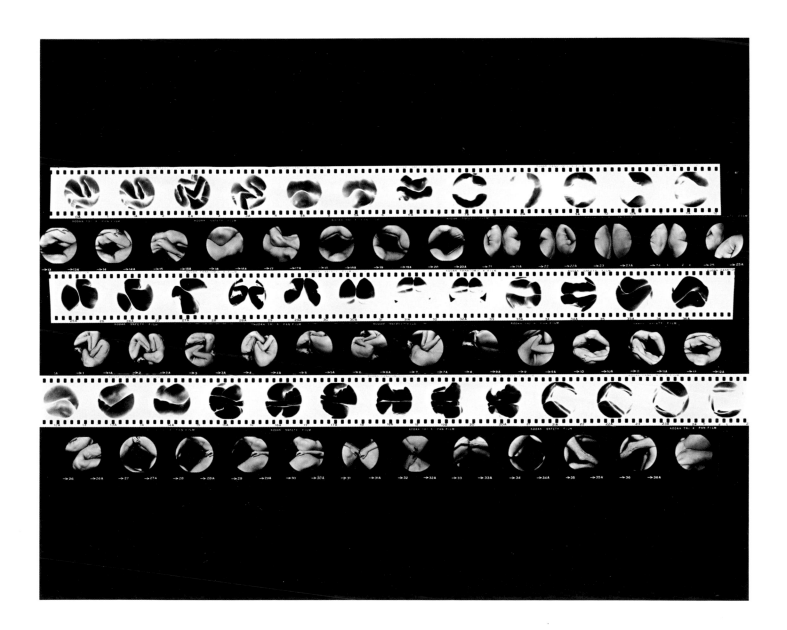

Cosmic Forms II, 1968, 40.2 x 50.4 cm 43

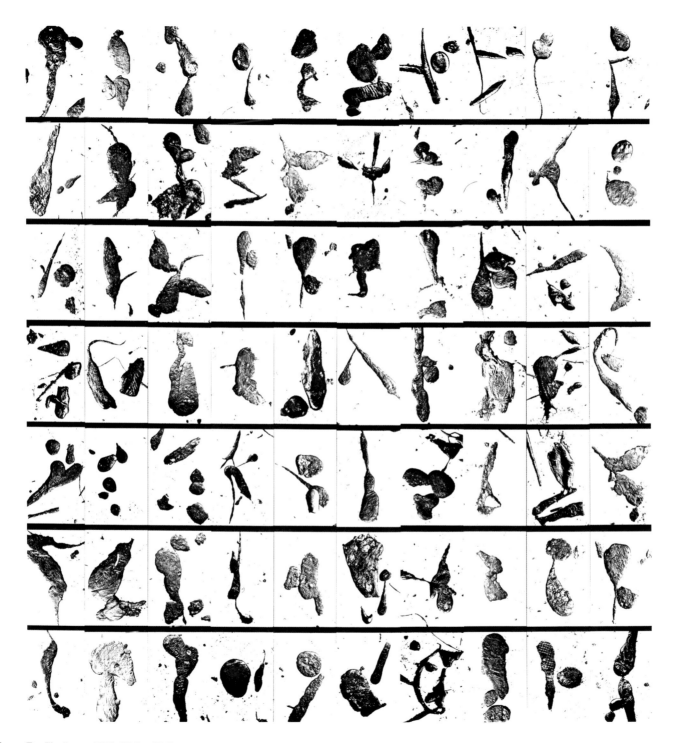

44 *Tar Findings*, 1975, 50.2 x 40.0 cm

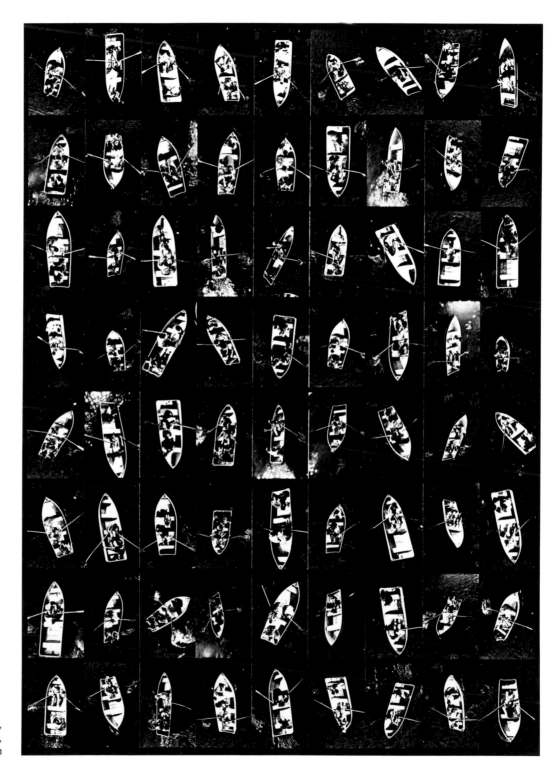

Rowboats, Lincoln Park,
Chicago, Illinois, 1978,
30.0 x 21.4 cm

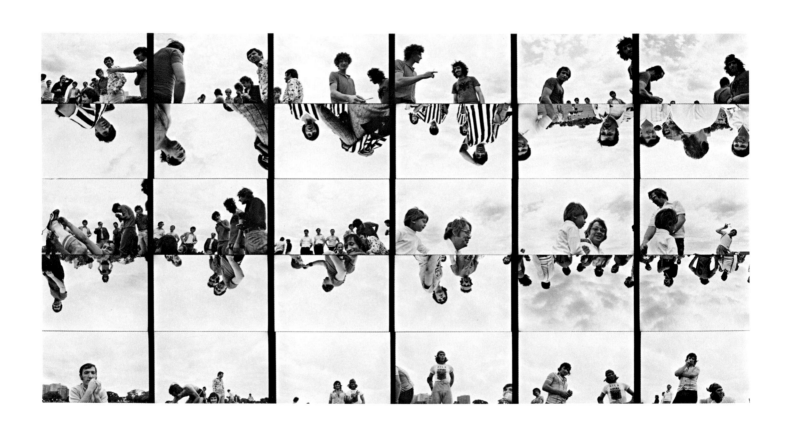

46 *Albanian Soccer Players,* Montrose Park, Chicago, Illinois, 1975, 11.9 x 22.7 cm

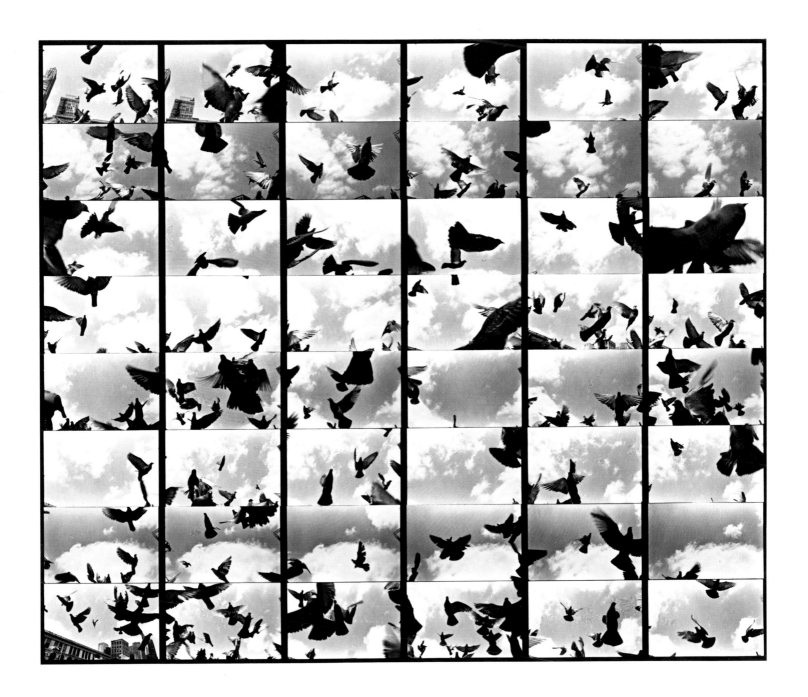

Pigeons, Grant Park, Chicago, Illinois, 1975, 19.7 x 24.6 cm 47

Wrightsville Beach,

North Carolina,

1971

Size of photographs: 34.1 x 27.4 cm

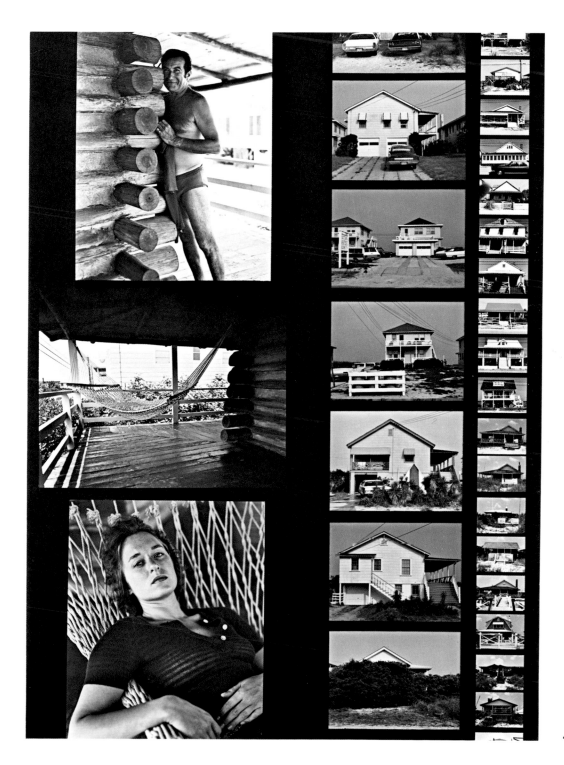

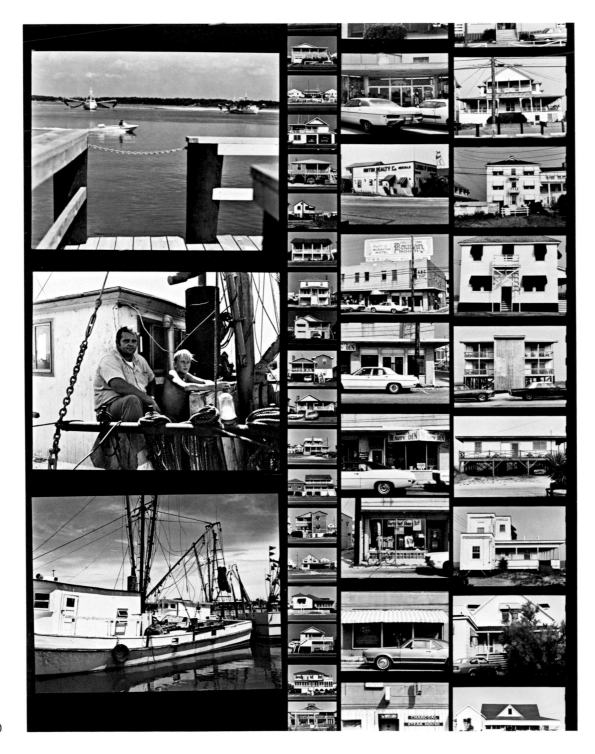

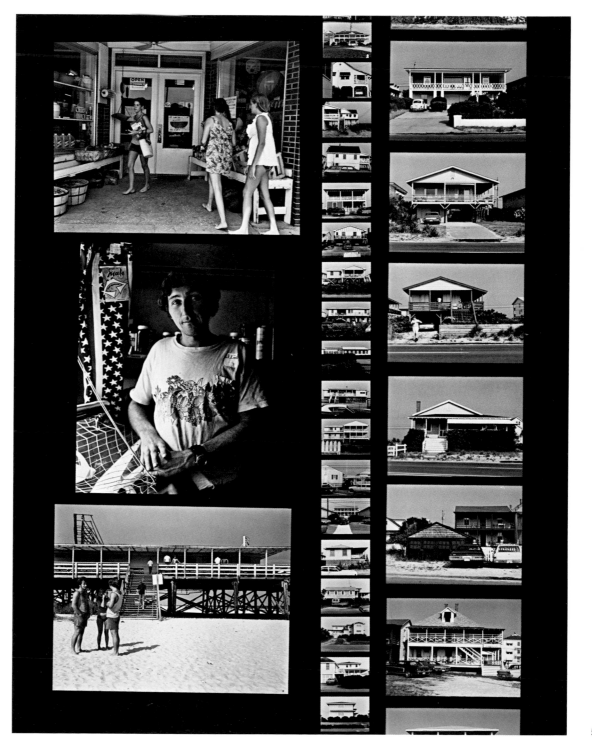

Combines

1974-1975

54

Blurred Tree, 1974,
50.2 x 39.8 cm

Winged Tree, 1974, 27.4 x 35.1 cm 55

56 *Phantom Image I,* 1975, 49.3 x 68.0 cm

Phantom Image II, 1975, 49.7 x 59.9 cm 57

Murals: Baxter/Travenol Labs

Deerfield Illinois,

1975

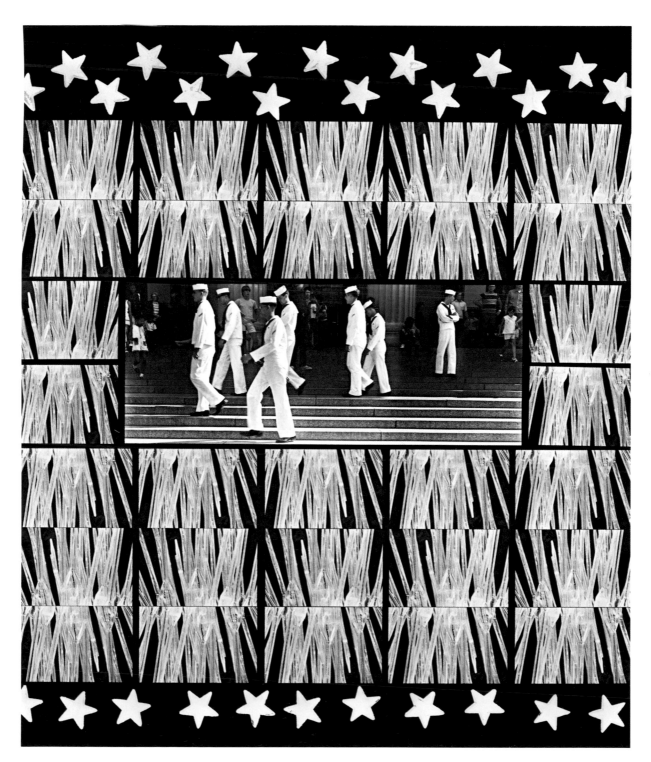

Bicentennial Polka, 1975,
print size: 50.4 x 40.2 cm;
mural size: 9 x 7 feet

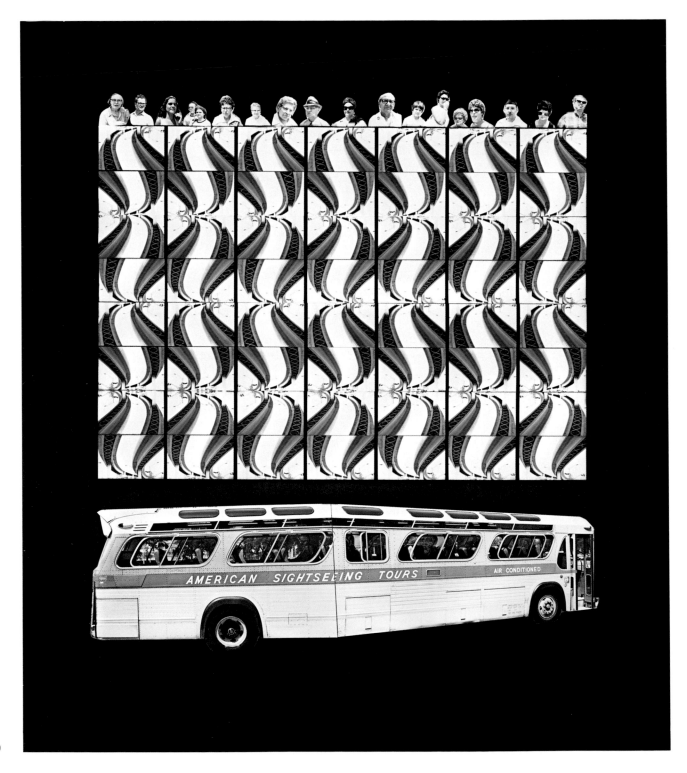

Bus People,
1975, print
size: 50.4 x
40.2 cm; mural
size: 8 x 8 feet

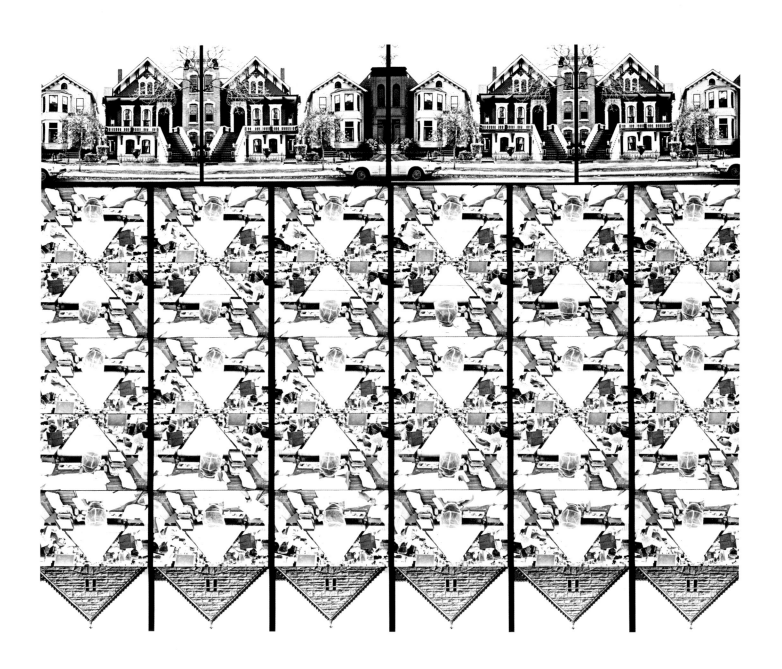

Victorian Assembly, 1975, print size: 38.3 x 46.1 cm; mural size: 7 x 9 feet 61

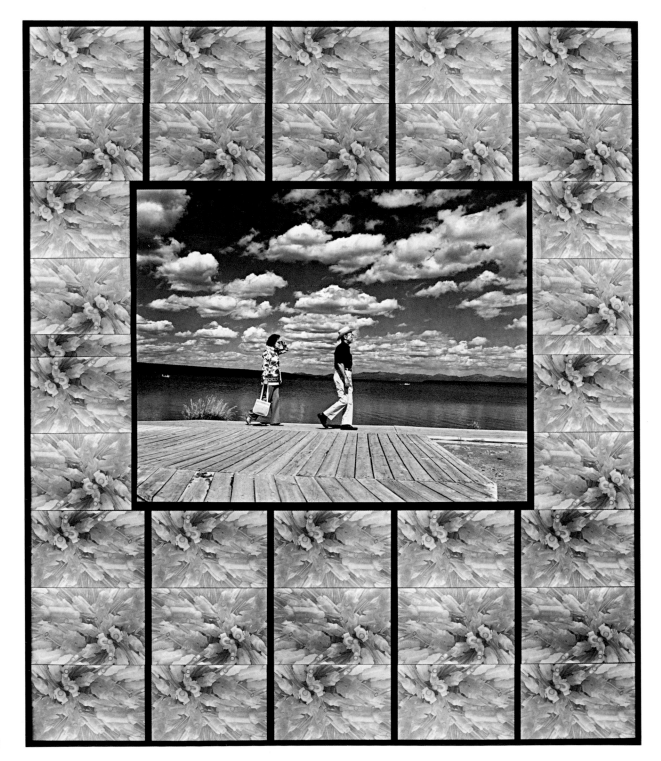

Right: *Just Married*, 197
print size: 50.2 x 40.0 cm
mural size: 8 x 8 feet

Left: *Boardwalk*, 1975,
print size: 50.4 x 40.2 cm
mural size: 9 x 7 feet

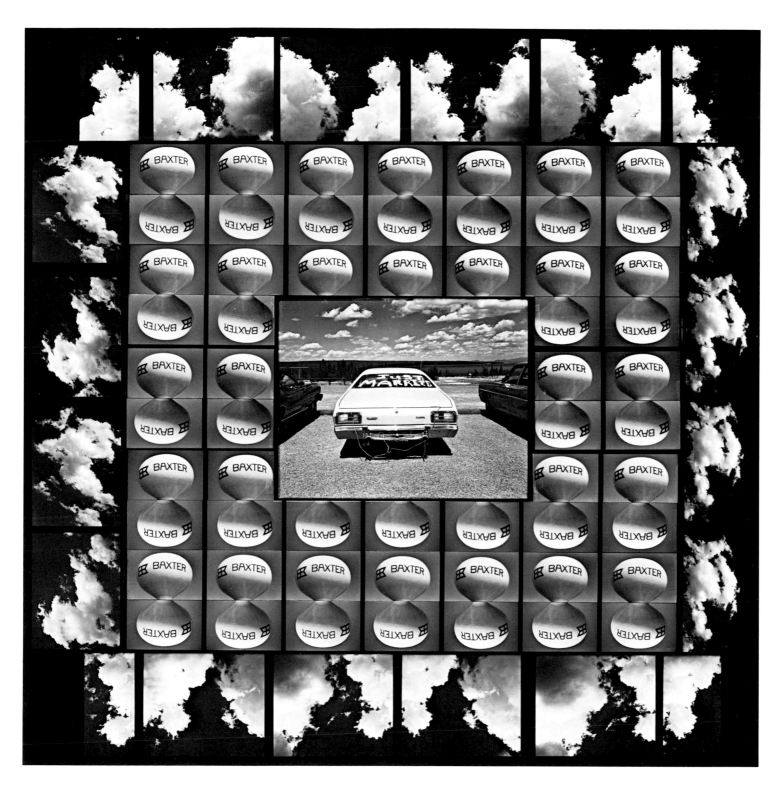

Petites Choses

1974-1975

Size of photographs: 25.0 x 20.0 cm, except where mat format alters

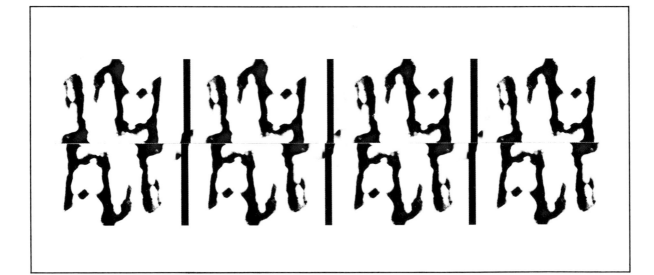

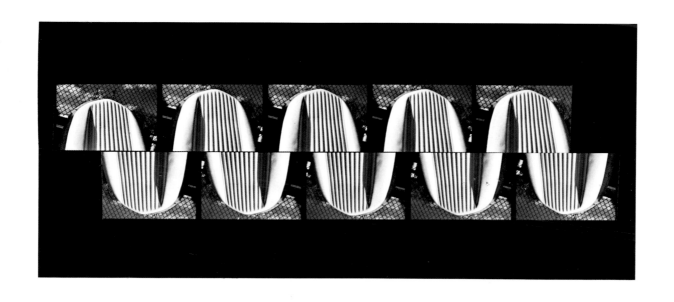

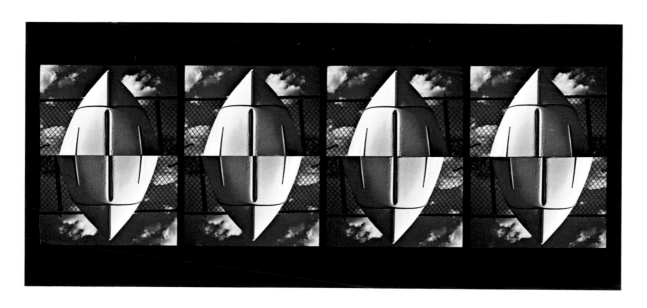

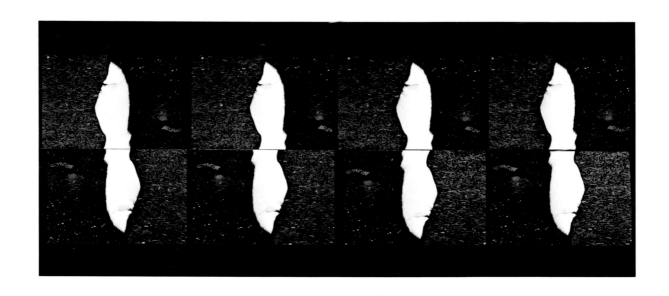

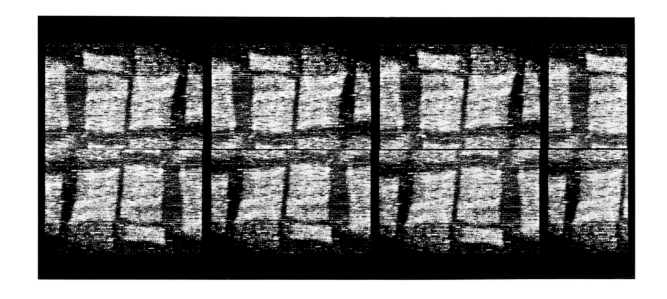

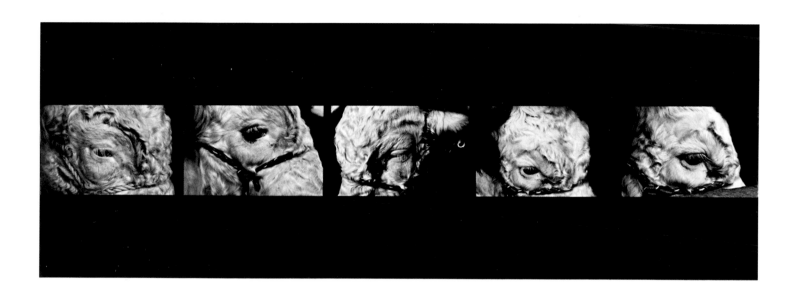

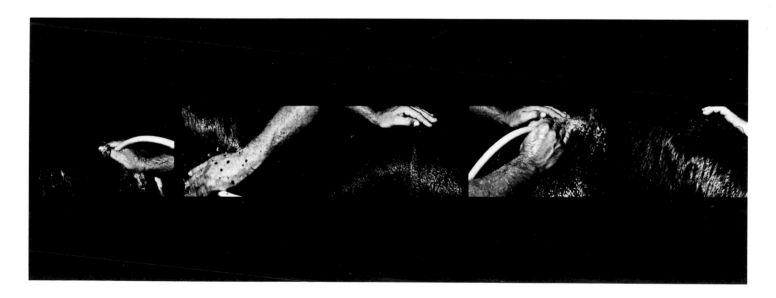

People of the North Portal

1970-1971

The photographs exist in several sizes: contact prints: 10.1 x 12.6 cm and
12.6 x 17.7 cm; enlargements: 27.8 x 35.5 cm, 40.6 x 50.7 cm, and 50.7 x 60.9 cm

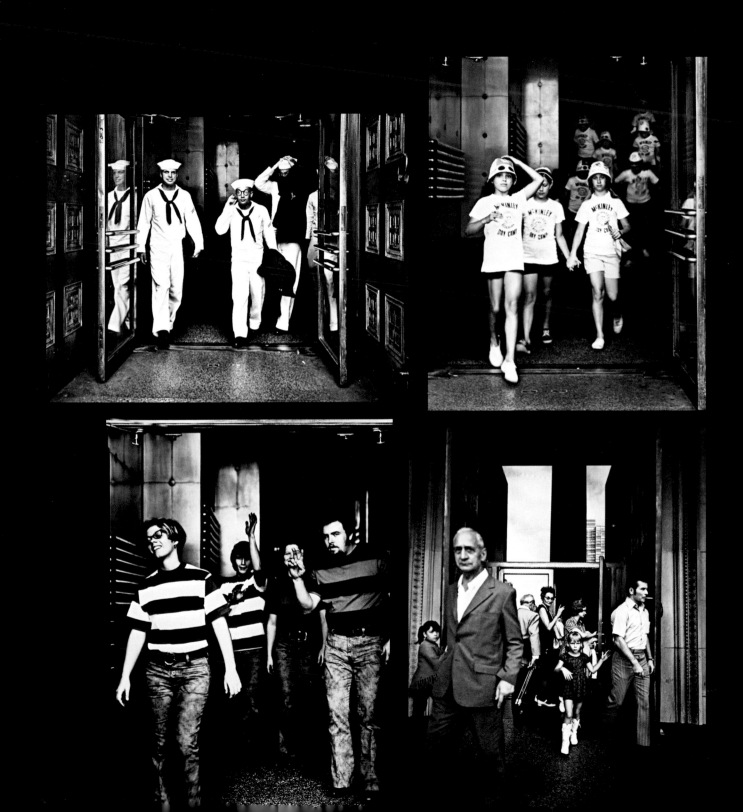

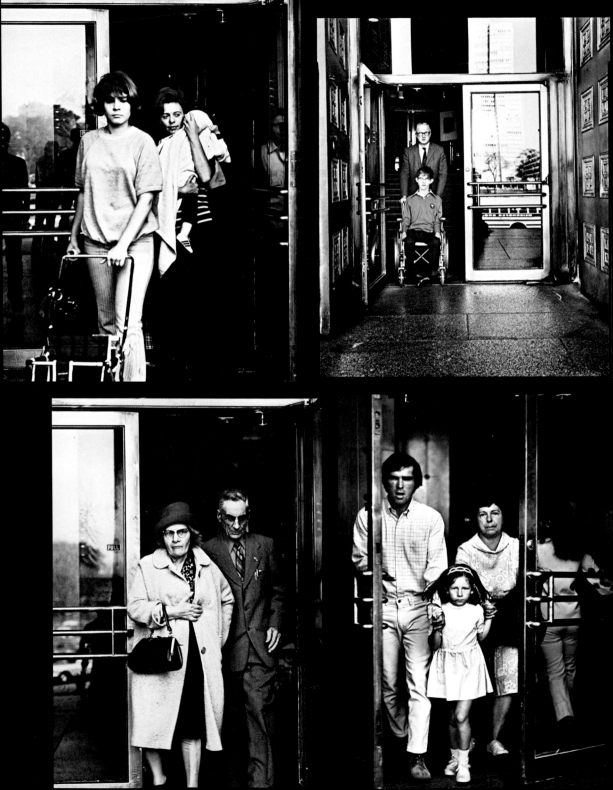

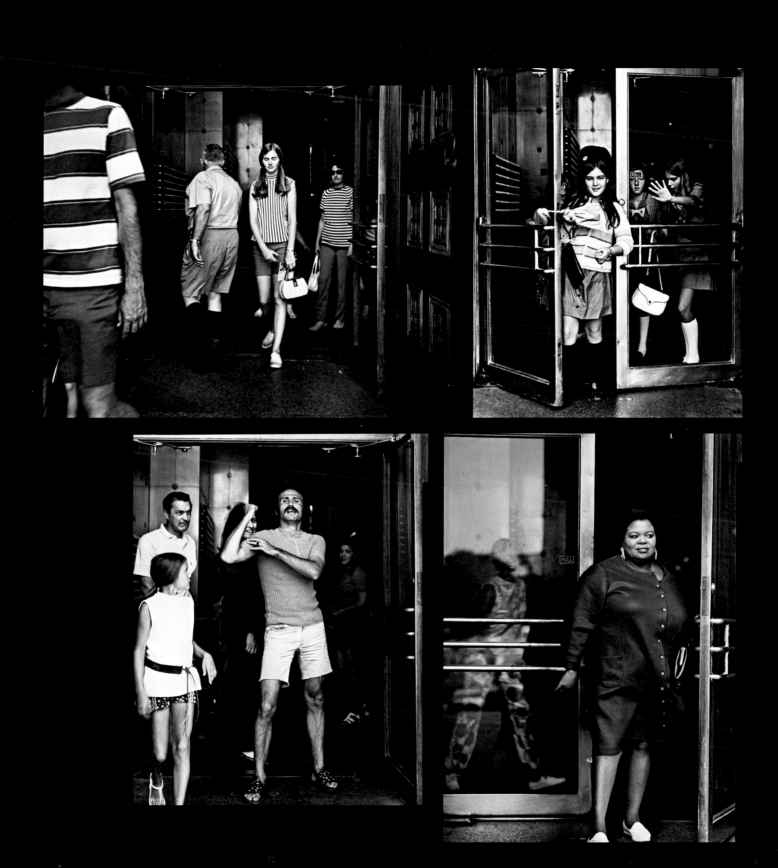

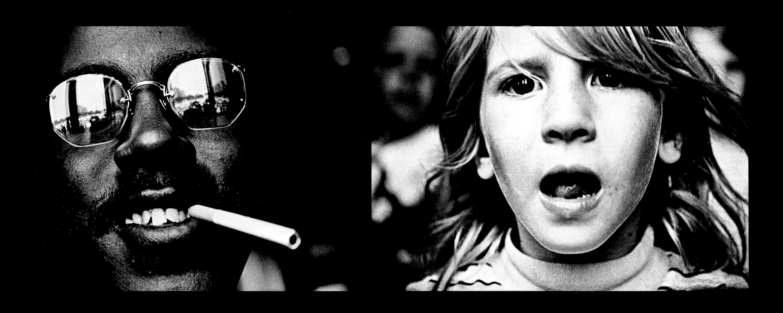
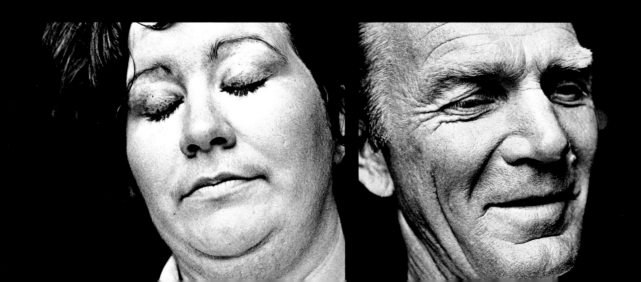

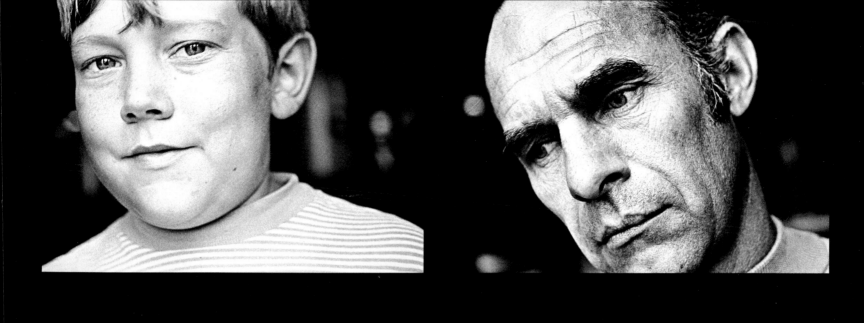
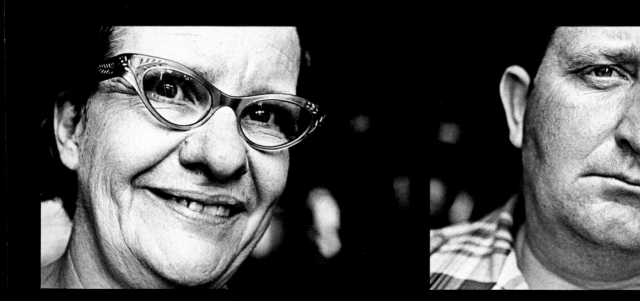

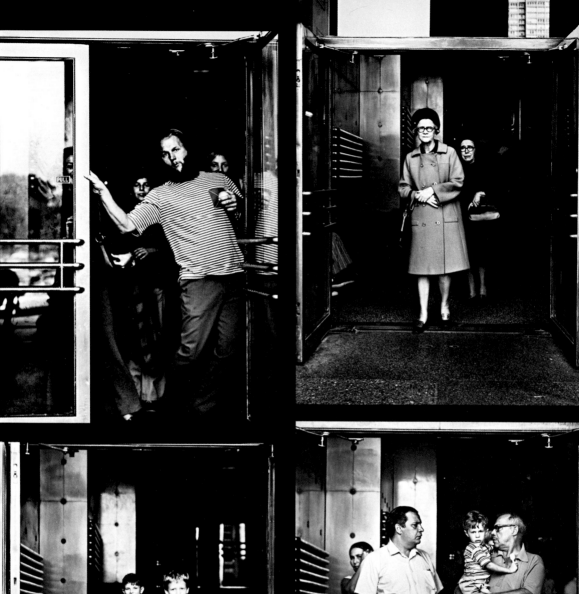
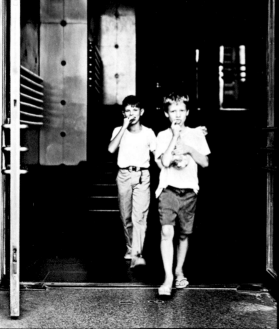

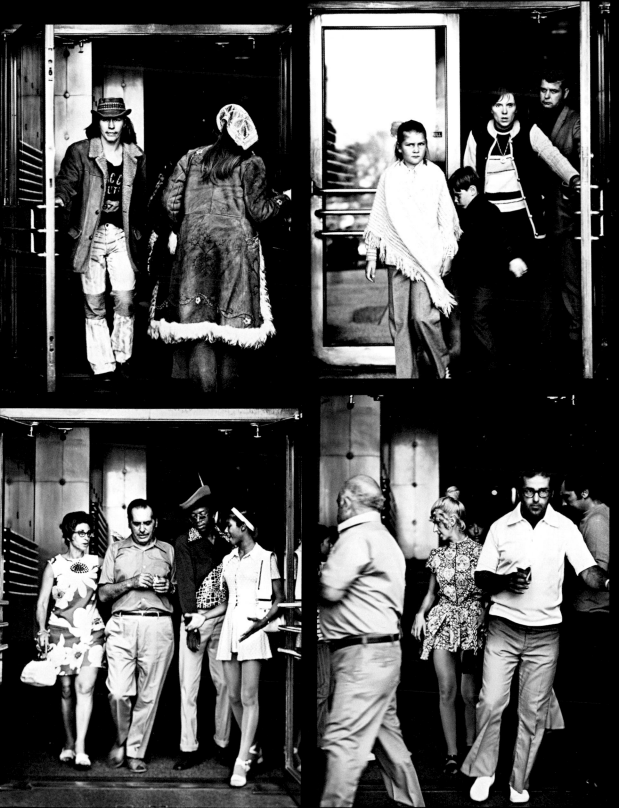

Architecture:

Chicago Commission on Historic and
Architectural Landmarks
1972-1979

*Door detail, William O. Goodman House,
1353–59 North Aster Street
in the Aster Street District;
Howard Van Doren Shaw, architect,
1914, 1975, 24.3 x 15.9 cm*

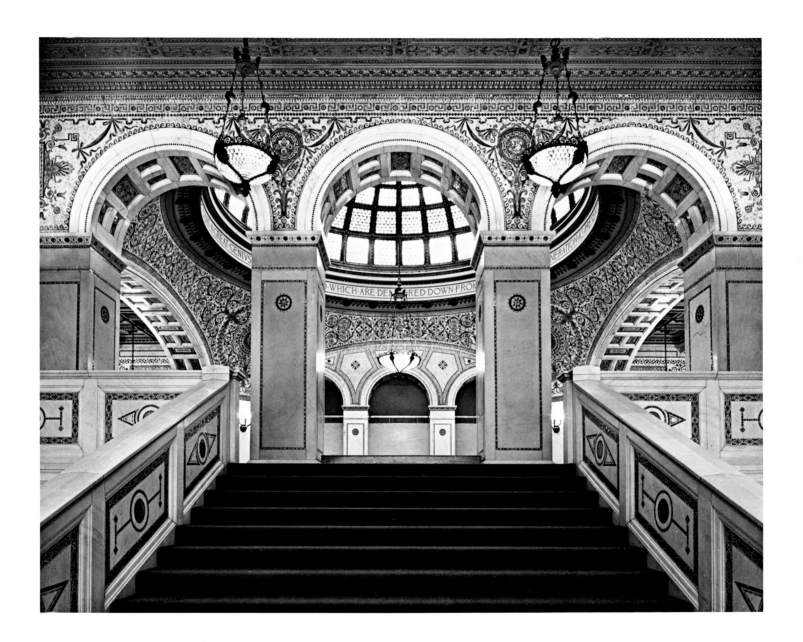

80 *Staircase to Preston Bradley Hall, The Chicago Public Library Cultural Center; Shepley, Rutan, and Coolidge, architects, 1897, 1976, 18.9 x 24.1 cm*

Main Staircase, The Art Institute of Chicago; Shepley, Rutan, and Coolidge, 1893, 1977, 19.0 x 24.1 cm 81

Chicago Loop

1976-1978

Size of photographs: 11.8 x 16.9 cm

84

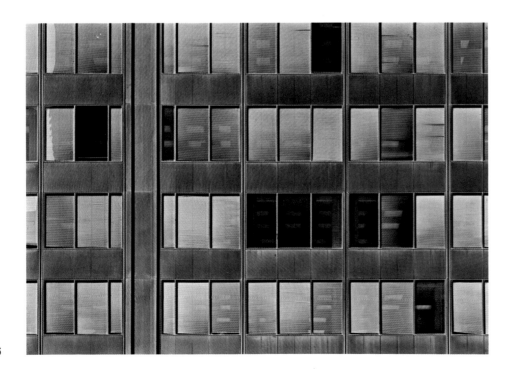

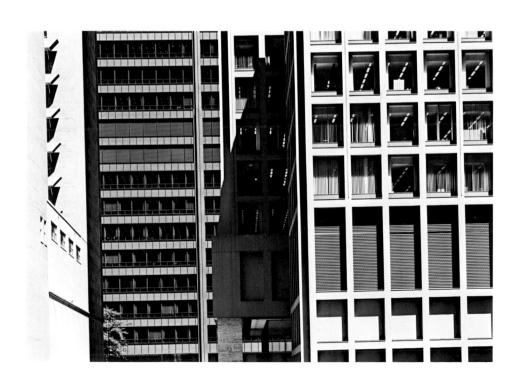

Chicago Beaches and Parks

1972-1978

Size of photographs: 26.6 x 34.2 cm

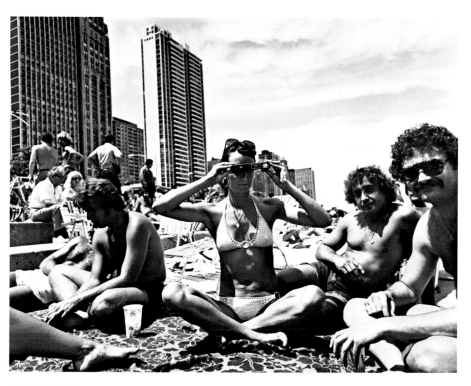

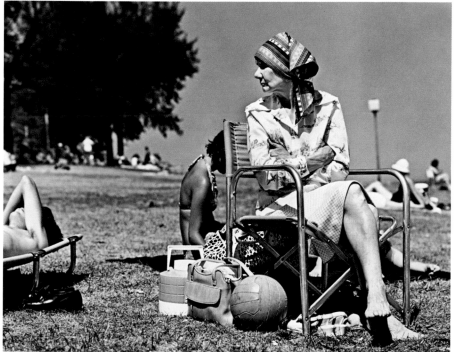

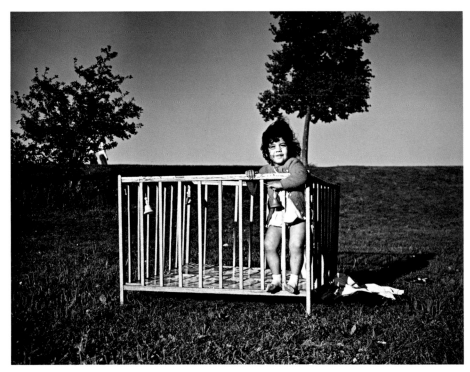

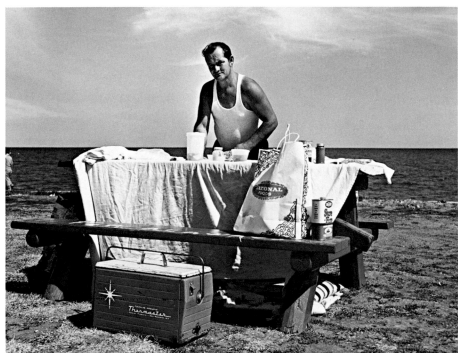

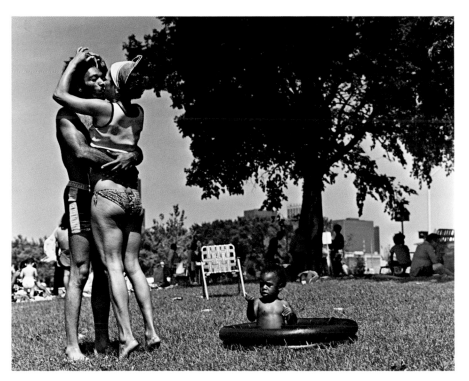

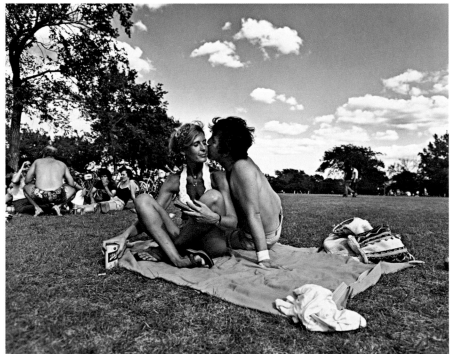

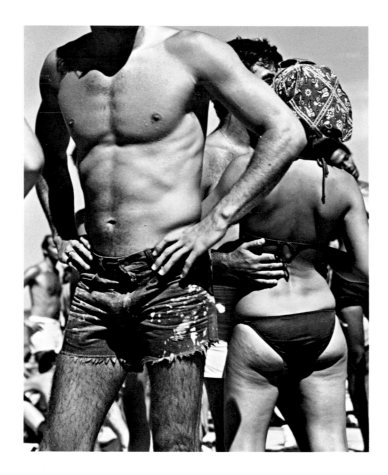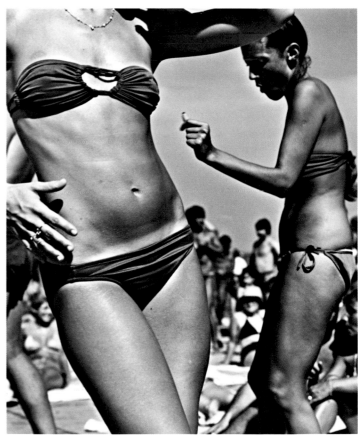

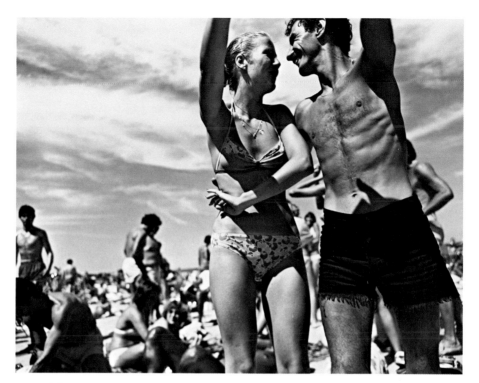

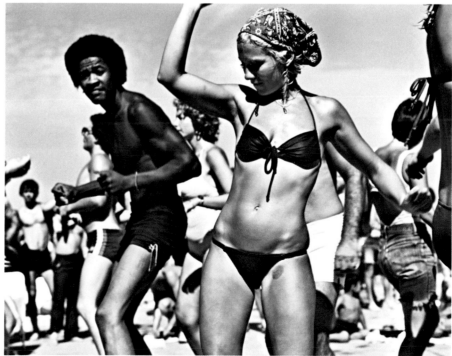

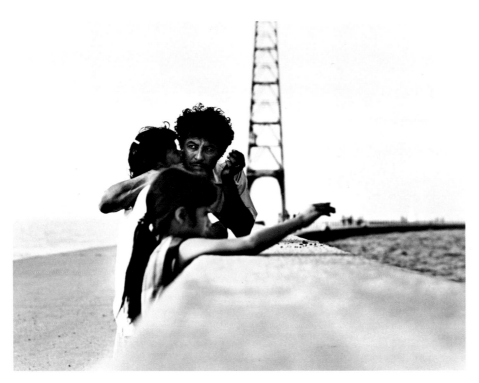

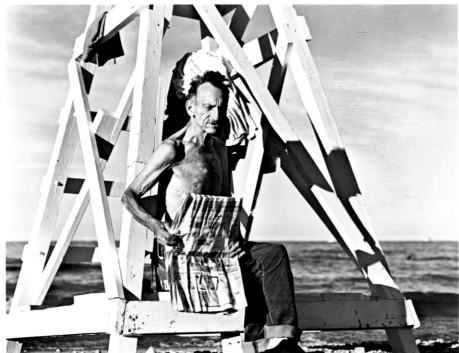

94

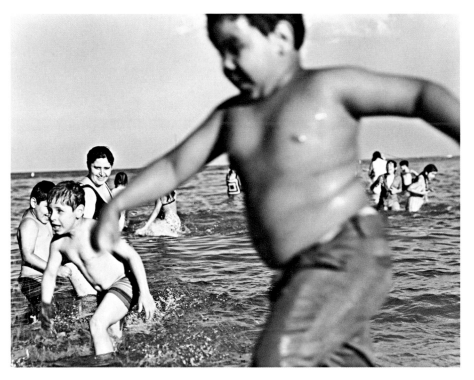

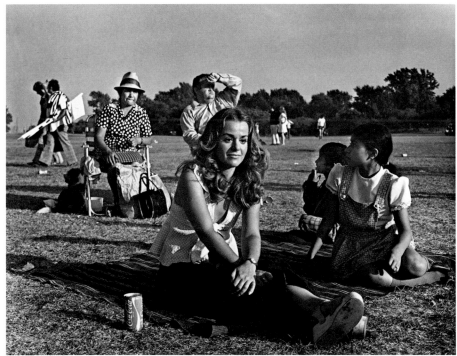

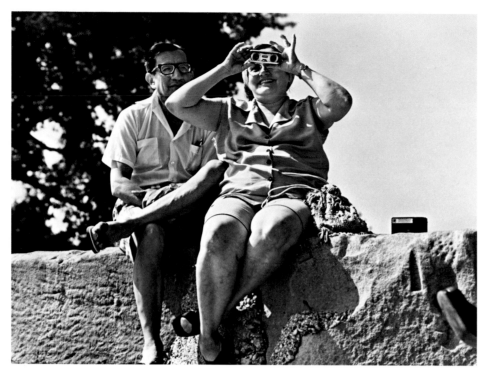

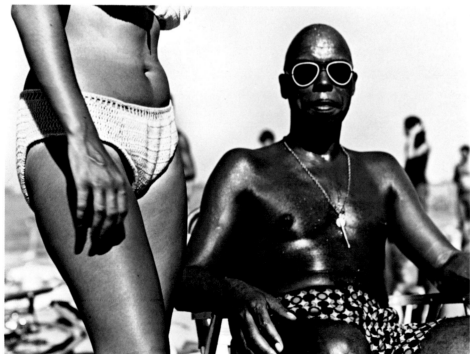

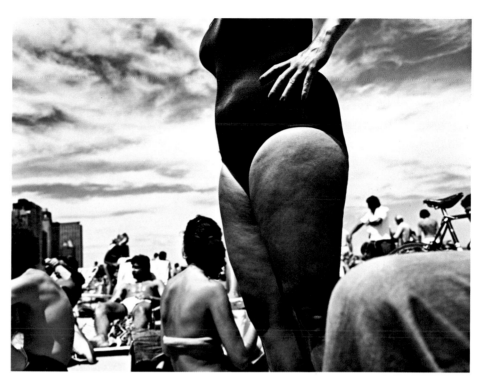

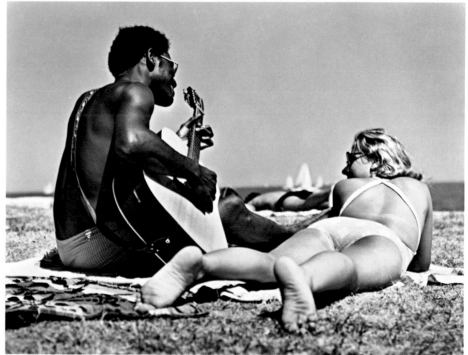

97

Commuter Discourse

1978

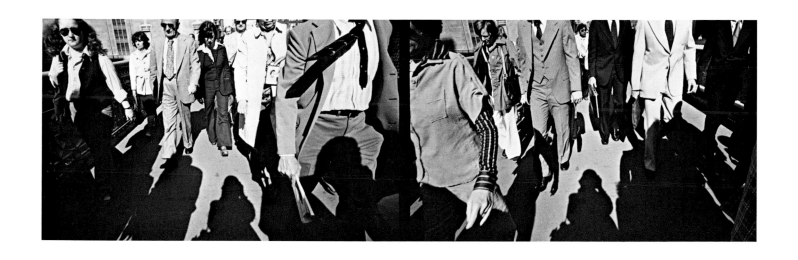

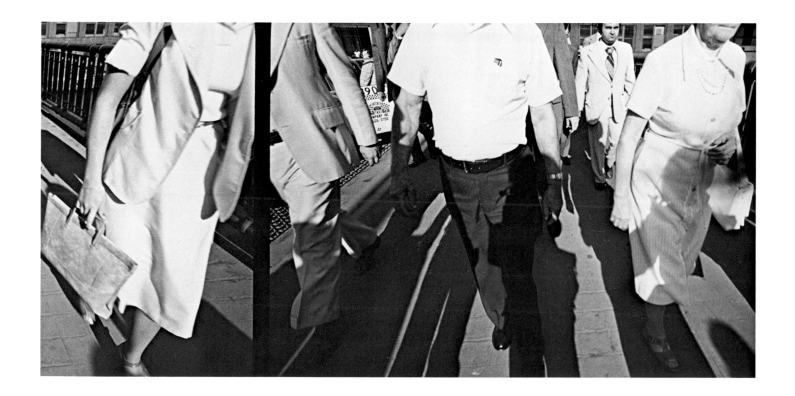

Top: Commuter Discourse series, 1978, 10.5 x 27.2 cm Bottom: Commuter Discourse series, 1978, 14.0 x 27.7 cm 99

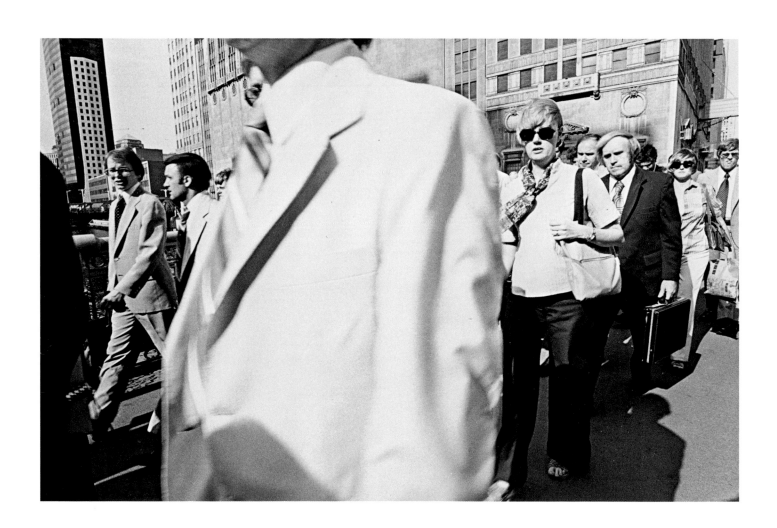

100 Commuter Discourse series, 1978, 18.1 x 27.2 cm

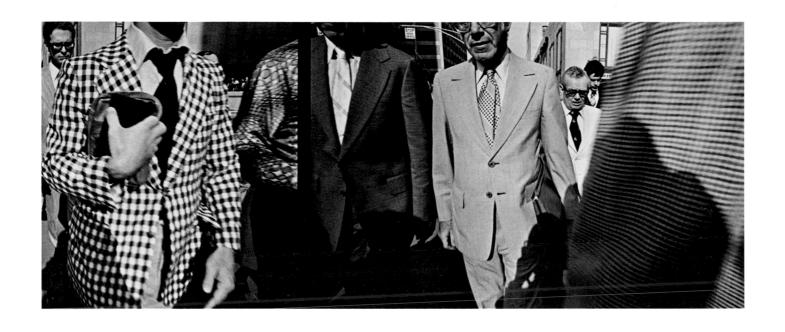

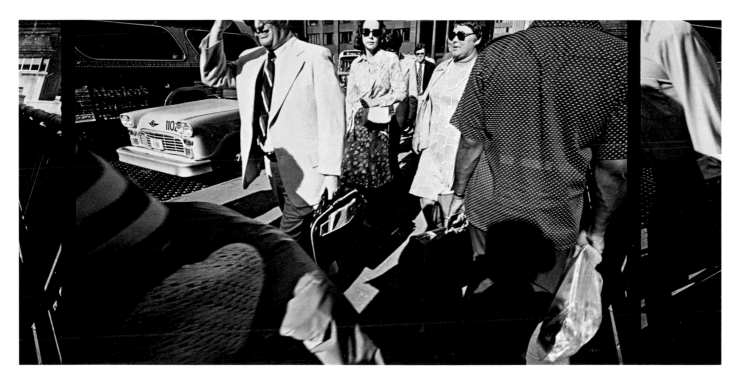

Top: Commuter Discourse series, 1978, 11.3 x 27.7 cm Bottom: Commuter Discourse series, 1978, 13.6 x 27.7 cm 101

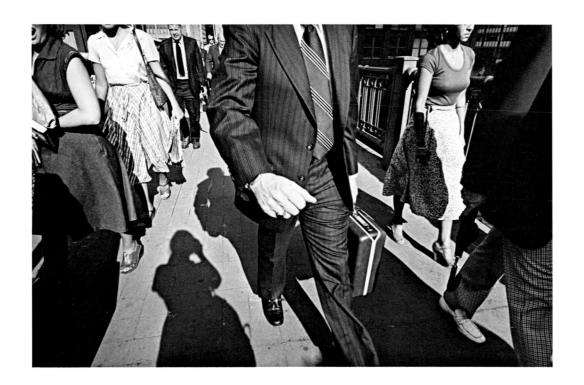

102 Commuter Discourse series, 1978, 18.1 x 27.2 cm

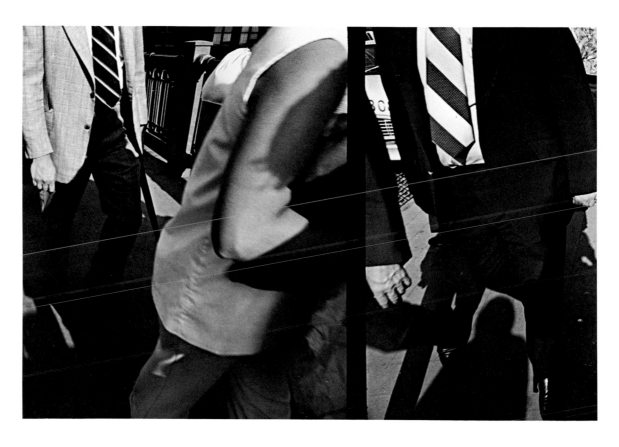

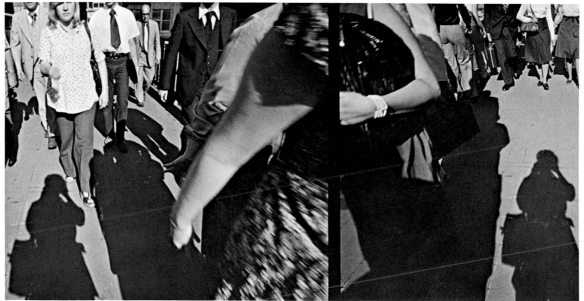

Top: Commuter Discourse
series, 1978, 18.1 x 27.7 cm

Bottom: Commuter Discourse
series, 1978, 14.3 x 27.7 cm

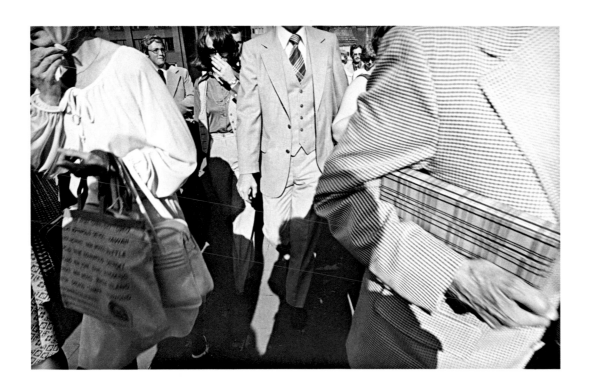

104 Commuter Discourse series, 1978, 18.2 x 27.7 cm

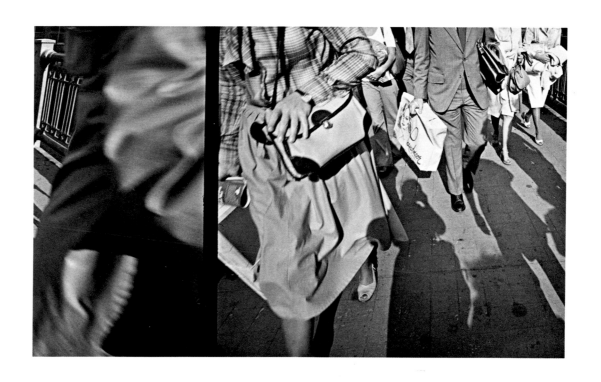

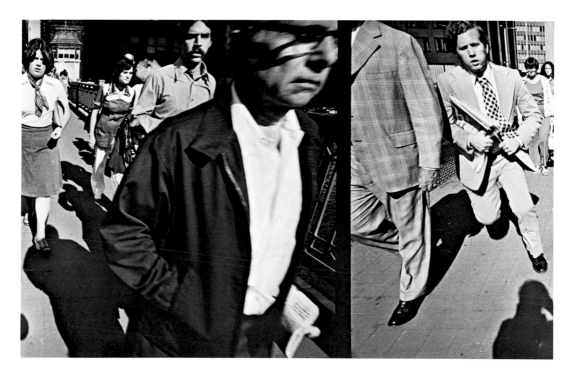

Top: Commuter Discourse
series, 1978, 17.0 x 27.7 cm

Bottom: Commuter Discourse
series, 1978, 17.3 x 27.7 cm

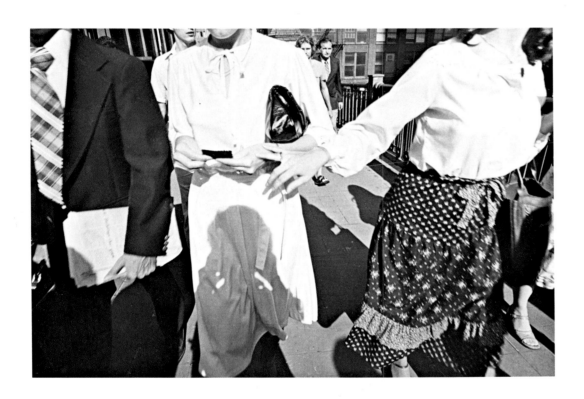

106 Commuter Discourse series, 1978, 18.3 x 27.7 cm

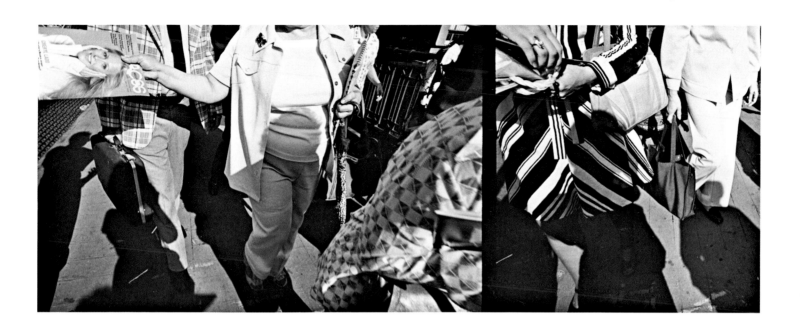

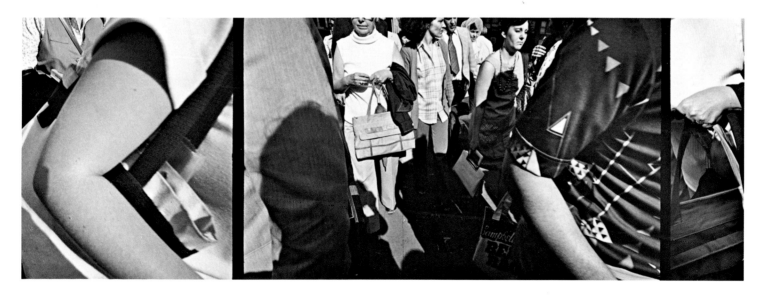

Top: Commuter Discourse series, 1978, 10.9 x 27.7 cm Bottom: Commuter Discourse series, 1978, 10.2 x 27.7 cm 107

Polaroid Polacolor 2

1979-1980

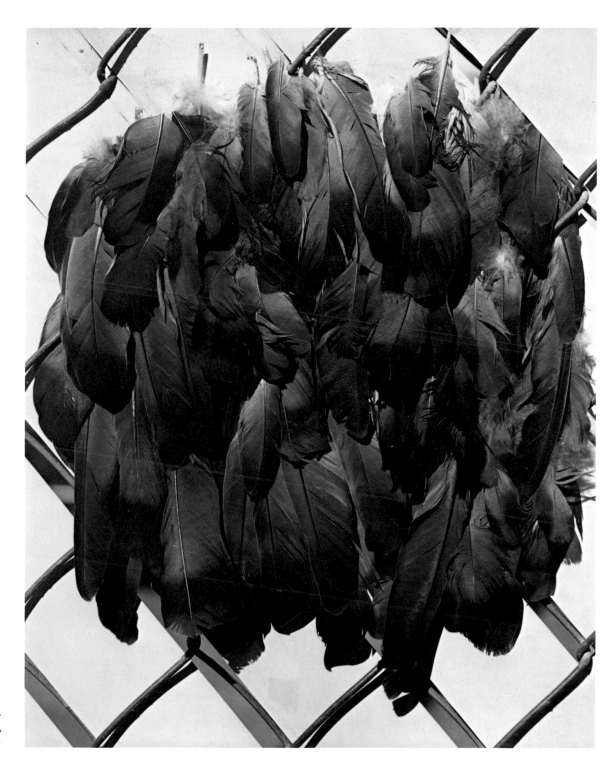

Pigeon Feathers,
On the Fence series, Tucson,
Arizona, 1979, 24.0 x 19.0 cm

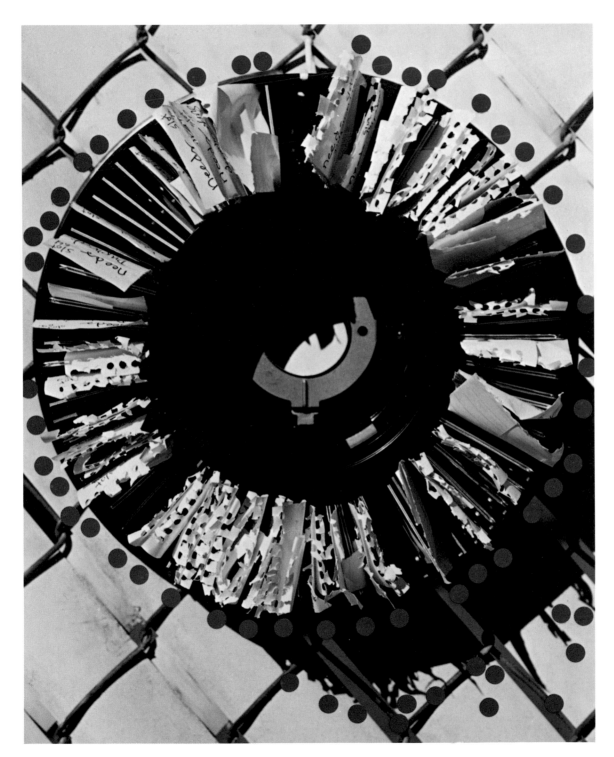

How To Make a Book,
On the Fence series,
Tucson, Arizona,
1980, 24.0 x 19.0 cm

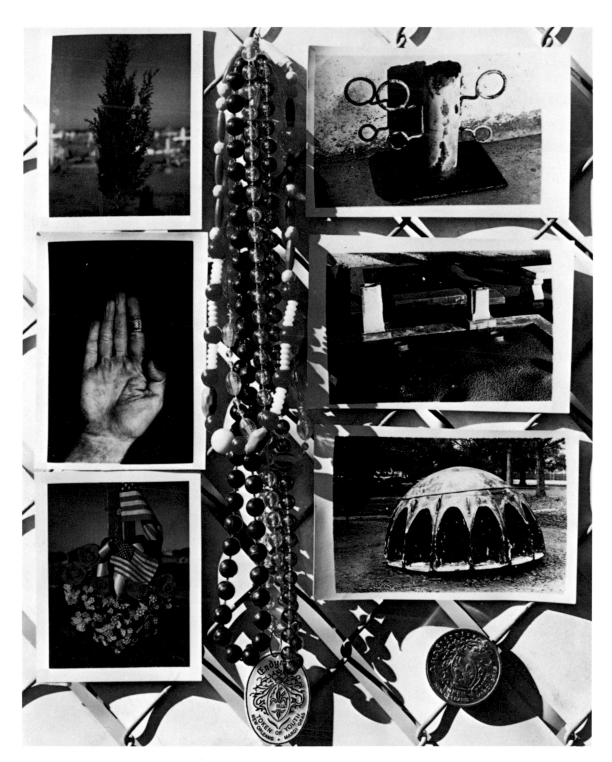

*Mardi Gras Gift from Richard
Owen,* On the Fence series,
Tucson, Arizona,
1980, 24.0 x 19.0 cm

Santa Barbara
(diptych with *Refrigerator*),
Tucson, Arizona,
1980, 24.0 x 19.0 cm

Refrigerator
(diptych with *Santa Barbara*),
Tucson, Arizona,
1980, 24.0 x 19.0 cm

Grandma To Be
(diptych with *Syracuse Pants*),
On the Fence series, Tucson,
Arizona, 1980, 24.0 x 19.0 cm

Syracuse Pants
(diptych with *Grandma To Be*),
On the Fence series, Tucson,
Arizona, 1980, 24.0 x 19.0 cm

Diptych from *Tucson Portfolio II*, 1980
each photograph: 8.9 x 11.4 cm

Upper left: *Papago Cemetery,* Mission San Xavier del Bac, Tucson, Arizona, 1979–80, 7.3 x 9.5 cm
Upper right: *Papago Cemetery,* Mission San Xavier del Bac, Tucson, Arizona, 1979–80, 7.3 x 9.5 cm
Lower left: *Papago Cemetery,* Mission San Xavier del Bac, Tucson, Arizona, 1979–80, 7.3 x 9.5 cm
Lower right: *Papago Cemetery,* Mission San Xavier del Bac, Tucson, Arizona, 1979–80, 7.3 x 9.5 cm

Upper left: *Maricopa County Fair,* Phoenix, Arizona, 1980, 7.3 x 9.5 cm
Upper right: *Maricopa County Fair,* Phoenix, Arizona, 1980, 7.3 x 9.5 cm
Lower left: *Swap Meet,* Phoenix, Arizona, 1980, 7.3 x 9.5 cm
118 Lower right: *Swap Meet,* Phoenix, Arizona, 1980, 7.3 x 9.5 cm

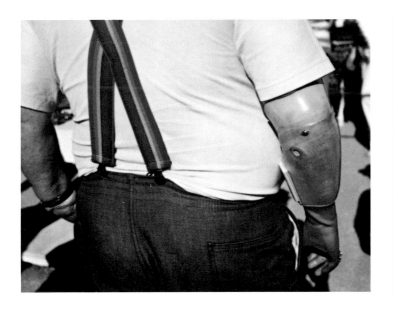
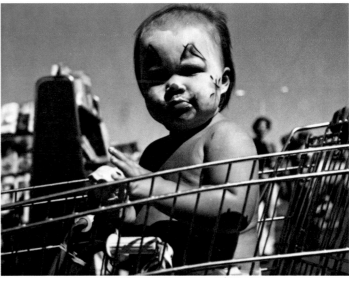

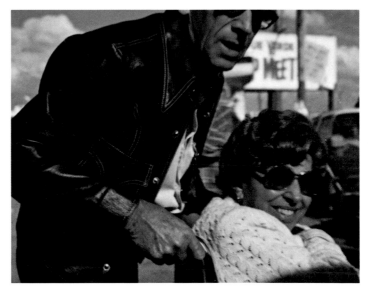

Upper left: *Tanque Verde Swap Meet,* Tucson, Arizona, 1980, 7.3 x 9.5 cm
Upper right: *Tanque Verde Swap Meet,* Tucson, Arizona, 1980, 7.3 x 9.5 cm
Lower left: *Tanque Verde Swap Meet,* Tucson, Arizona, 1980, 7.3 x 9.5 cm
Lower right: *Tanque Verde Swap Meet,* Tucson, Arizona, 1980, 7.3 x 9.5 cm 119

Recollections

BY PAUL VANDERBILT

My first connection with Barbara Crane's prolific output came when she wanted to show me her People of the North Portal series in 1973. I was on the program for a conference in Louisville, and she wrote to me, saying she was going to be there and had some pictures she wanted me to see. I knew her name. I had met her casually and was familiar with only a few of her works in reproduction. She was to me but one of many photographers who are recognized as the background framework of contemporary American photography. Barbara never made it to Louisville for the meeting, but later visited me at my home in Middleton, Wisconsin, and we talked about North Portal.

I wish I now had a perfectly clear recollection of those first conversations, which may have been nearly monologues on my part. I don't think my opinion has changed much. I both liked and disliked those pictures and was trying sensibly to separate and pin down this conflict in reaction. I had a somewhat adverse feeling about the pictures themselves, but I felt an immediate enthusiasm for the project that brought them into being. There was something behind the photographs, something mysterious and otherworldly about the rationale of this undertaking that fascinated me. It was the intensity of the whole thing. Any commitment so involved, so prolonged, had to be something pretty special, and I was intrigued rather than put off by my own inability to finger just what that special quality was. I knew that I was looking at something very like the bottom line. Barbara's wish notwithstanding, I could not accept her claim that the validity lay in the photographs themselves. The pictures were very literal, very immediate; however, I felt that I was face to face with a hypnotic situation in which the subjects vanished, leaving me with a metaphysical proposition of the first magnitude. This reaction was intensified as I became familiar with her subsequent projects. Barbara has her eccentricities and I have mine. One of mine is that I think of photography as a whole, as an activity on the part of many people, as millions of fixed and tumbling images, and not as a limited, precious treasury of a few portfolios of individual masterpieces. The

121

individual images of Barbara's that I most often prefer are invariably from a long, intensive series, and I know that one could not come into being by itself, but only as the result of a prolonged and varied exercise — a loving feeling for the essence. I see the whole but remember the one and know that one to be memorable because it is more than itself.

For a long time, in fact several years, I had in mind to write a text for the People of the North Portal series, and I worked on it. But it never came out the way I wanted and probably never will, though some glowing coal, some unresolved challenge still remains. That face. Is it photography or is it humanity? What I had in mind was a running text of a factual and background nature, broken at intervals with passages indented and in a different typeface; it would be of a stream of consciousness, both of Barbara's own pain, for it was that, and fragmentary dialogue, supposedly from this burst of humanity in their passage across the stage, a theme that was to recur with a different scenario in later projections of Barbara's Commuter series, engulfed in the nonstop onset of strangers:

> This man in the back seat, he was a political candidate and he asked the taxi driver what in this country bugged him the most. And it set me thinking. I'll tell you what bugs me the most. It's asking for a little information and not getting a good answer or being put down and laughed at.

I thought the gathering of material would be difficult, but it was not. And I thought the sequencing would be shaky, but it fell into place on the first try. What made it hard was my conviction, from the outset, that there was a latent philosophical aspect here, a question of sign and realization that had to be dealt with, without which no one would see these randomly spaced people in any role but exiting through a stage-like door. I was faced with a problem that has bothered, but interested, me for years. In the case of an inspired and introverted passion and not of a common cliché,

assuming that a photographer has "put" so very much into a picture (or a long set of pictures), does any viewer, under any circumstances, lacking background information, without something beyond the image as such, really get anything like what the photographer meant to add as personal reaction to the content of the picture itself? So I thought there had to be a text, like a sound track, and a handle, not in the sense of title, but a connection to keep it from drifting. There would be one long continuous sound.

> Some people have like overloaded circuits and just can't hold on to all that's happening. Not accurately. They get struck by certain things, but the whole picture — no way. You have to put first things first and some people just don't have all that capacity. Some have gigantic memories and don't miss a thing, up to a point of course, and others just have a few wires, and some of those loose, and they just don't notice when something changes and a new team comes on.

The commitment to series rather than single pictures is perhaps the most strikingly innovative quality of Barbara's work. Not that series as such are innovative, but it is in the nature of her series and the ways they were put together, in the essentially philosophical contention that the ephemeral, immaterial subject, far from being in any one of the momentary images, is not even possible in the limited series, but only in an infinite projection beyond the pictures themselves.

Unfortunately, a book format does not accommodate reproduction of Barbara's long roll, a 10× automatic enlargement onto a single continuous roll of paper of thirty-six color negatives of a sailboat, only a few yards in front of the camera, passing a point in the harbor. I can imagine what a good filmmaker might do with the image of Barbara on her hands and knees unrolling the event on the floor (it takes an entire living room, a hallway, and a cleared dining room). We can see the sections, the individual frames, evolving

shape by shape, like punctuation marks in wonder.

With no loss of wonder and no concession to mere design, the fascination with multiplication and cumulative effect came to dominate a period of her work. It was an intensive exploration of all the variables within a parameter to the point where the basic subject, obviously still there, nonetheless disappeared, and there remained only the variableness of its suggestive potential. It was an anti-monumentality, a revelation of what lens-vision can do to relative scale.

The fertility of this period yielded images in line, in juxtaposed layout, in overlap, and in superimposition. Did you ever try, as an exercise in concentration, to superimpose two or more unconnected thoughts so that they are not following one another but are actually simultaneous, as in a multiple image? It appears impossible, but maybe all thoughts actually start as a blend, their forms only recognized as the figures are disentangled.

Running throughout all these convergencies and overlaps, there was always a strong suggestion of "otherness." The "other" may be wanted, very intentional, as the distinguishing identity, or it may be the price of that very privilege or, more tragically, more creatively, the infusion of a symbol with sufficient power to overtake the original that is out of reach.

Multiples, series, random findings, shutter effects, the "other" posture — all these are obliques (not near, not middle, not far), and the element they have in common is what they are not. Some artists, Barbara among them, can work on several kinds of obliques, but consecutively, not simultaneously. I wrote to her:

Dear Barbara,

You know that my reading of the world's literature is biased in the direction of irregularity, of unpredictability, and not in the direction of good, sensible stock conformists, following "good advice," and thus I find ways to sustain and encourage you. I'm always trying to find within art a principle of judgment superior to the principle of precedent. What is right in this particular case today, all other cases notwithstanding? When something is right in a work of art, it is irrevocably right in a way that is distinct from any doubt with which it may be charged. If I sometimes seem to react only mildly to design, it is because I think you are usually beyond design. I am seeing, instead of those images which are indeed wonderful, but left at that, some particularity, the "image" of invitation, of interdiction, of effervescence. I think of emotion as non-design. I am looking at one of your finest landscapes, the Moonrise at Great Punched Card, and I know that the height of the mountain has to do with the perception of detail, the vines and rock surfaces, just as in *The Crust,* the line which has no endeavor, no analysis, will spread that landscape all over my life.

This "otherness," a zone system of falling and placing reaches of reference (rather than tones), determining scales by their extremes, putting the exceptional where the standard is expected, will in the end serve you (and your pupils) well; for how else is one to learn the degree to which things are not what they seem.

Photography may deal successfully with the essential philosophical problems, not solvable by words and thus "not solvable." Philosophy has been male-oriented, toward systematic solution. Photography's "otherness" may make the most of feminine-oriented, unlimited, unsystematic unreason; may make peace with insolubility — so that to say a "problem" is insoluble is not to dismiss it, but to give it a multiple texture. If a thing or an event is not what it seems, what then is it? It's a photograph. Identity hardly matters. The thing it is not is in turn not what that seems, and so ad infinitum. Where the mind stops, the lens takes over.

— PV

As artist-in-residence at Apeiron Workshops, I

123

picked up two significant points. Both are conceptual ideas apparently of currency in at least some academic circles, but new to me because of some lapse in my reading. I am not through with either one. That is what's valuable: they are worth working over to see what each in turn seems not to be. It was, for one thing, new to me, perhaps surprisingly, that every still photograph is an image of time as well as space. I had to work this out for myself, often using some of Barbara Crane's pictures to test the way. I came out with the thesis, which may not be orthodox, that in every image, even of the most rigidly static "subject," there is implicit an action, perhaps only of being, and that the time represented is the time, not necessarily linear, for that "action" to run its course: that is, the interval between the aspect shown and the next. That face looking straight at you is there until one of you surrenders. And I have come to wonder whether that time may not be a negative quantity, a kind of time turned back into itself, the interval between a preceding eternity and the moment of exposure.

I am looking at one of my favorites from among Barbara's hundreds of sudden incidents along Chicago's lakefront summertime, a picture I have long had tacked up by my desk, wanting to write about it. The time is retrogressive, back to the moment before. Originally it was, we presume, a tableau. And then? The positivist ethic requires that a picture go from No to Yes, and here the accident has not happened yet and we are only at the warning. You can show the trap set for the springing and you can show the death; you can even catch the trap closing, the guillotine released and falling. But I cannot recall a single newspicture, the photographer dealing in such emotional contraband, in which what you thought you saw is cancelled and you are taken back a step in premonition.

Furthermore, at Apeiron I was introduced to the doctrine that early man, say at about 10,000–8,000 B.C., before his conquest of the earth, was in his best spiritual and ecological balance with the universe, that he had knowledge as a natural function and that his history since then has been a desperate, pretentious, and probably futile effort to regain that lost adjustment. My weighing of this view somehow becomes associated with the Commuter series, for instance, the tiny spotlighted figures crossing the immense black screen in a theatrical lockstep, or the triptych onrushes boiling over the photographer, making for the sun, the endless conveyor belts with energies stampeding to expiration. The time in those daily migrations is the time it will take a silent collective to pass a given point in a straight, pulsating line, and that is not forever, but only to the outer limit of our present concern. Every question of religion is raised; every rightness in art is affirmed. It is an hourglass filled with human sand, and there is no way it can stop running.

I often wish there were some way in which a photograph could go directly to its intended target, like a welcome letter or a telephone call, directly to a specific person at the precise moment that recipient is ready for it. We all want to speak to the world, and all these exhibitions and publications are a wild sowing of seed in that direction, a blind hope that some random wind will drop a meaning where there has been a corresponding personal struggle. We need to do more intimate giving, if not of physical prints, then of content, for it may be the function of the world to be seen by photographers.

PAUL VANDERBILT

DESIGNED BY MARK SANDERS
COMPOSED IN PHOTOTYPE HELVETICA
DUOTONE CAMERA-WORK BY WILL HOWE
PRINTED ON WARREN'S LUSTRO OFFSET ENAMEL
AT THE PRESS IN THE PINES

NORTHLAND PRESS/FLAGSTAFF, ARIZONA